IMAGES
of America

PAWLEYS ISLAND

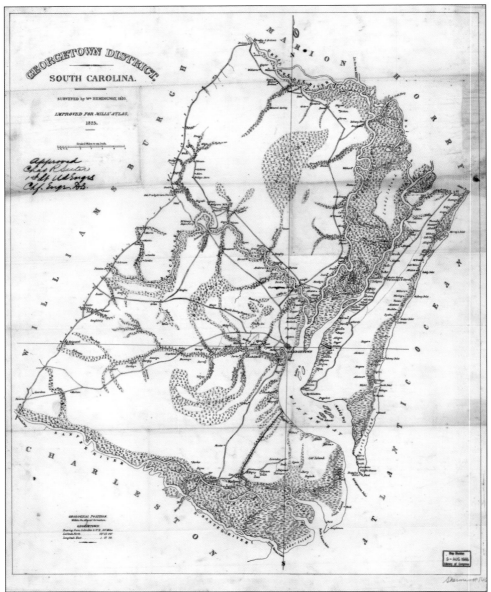

This map from 1825 shows rice plantations, clustered along the Waccamaw River, owned by families named Allston, Ward, Tucker, LaBruce, and Pawley. Many of these same families also owned land at the "Canaan Seashore," the creek-side settlement where the first summer homes were built in the area. On this map, Pawley's Island is the strip of seaside land between Midway Inlet and Butler Inlet. (Library of Congress.)

ON THE COVER: Esther Sampson Kaminski relaxes on the porch of her Pawleys Island home, originally built in the mid-19th century as the Summer Academy of All Saints Church. The Sampsons and Kaminskis were both prominent merchant families in Georgetown. Esther's daughter Charlotte Kaminski Prevost is the coauthor of *Pawleys Island . . . A Living Legend.* (Kaminski Prevost Collection.)

IMAGES
of America
PAWLEYS ISLAND

Steve Roberts and Lee Brockington

ARCADIA
PUBLISHING

Published by Arcadia Publishing
Charleston, South Carolina

Printed in the United States of America

Library of Congress Control Number: 2018931244

For all general information, please contact Arcadia Publishing:
Telephone 843-853-2070
Fax 843-853-0044
E-mail sales@arcadiapublishing.com
For customer service and orders:
Toll-Free 1-888-313-2665

Visit us on the Internet at www.arcadiapublishing.com

*To our friends and neighbors in Pawleys Island, especially Harriett
Plowden and the late Gen. Bob Plowden, Mary Lou Joseph Kenny
and John Kenny. And to Arthur Herbert "Doc" Lachicotte Jr. and
Alberta Lachicotte Quattlebaum, whose lifelong work in preserving
the history of this community helped make this book possible.*

CONTENTS

ACKNOWLEDGMENTS

This book could not have happened without the enormous effort and dedication of Julie Warren, project director of the Georgetown County Digital Library. She has our deepest gratitude. The many photographs we used from the library archives are marked GCL. Lizzie McKee, director of the Georgetown County Museum, was also very helpful, and photographs supplied by the museum are labeled GCM. Many others contributed to this project and deserve our sincere thanks: Dwight McInvaill, director of the Georgetown County Library; Beth Bilderback of the South Caroliniana Library; Charles Swenson, editor of the *Coastal Observer*; Robin Salmon and Wendy Belser of Brookgreen Gardens; George Chastain, director of the Belle W. Baruch Foundation at Hobcaw Barony; photographer Tanya Ackerman; Bill Otis, former mayor of Pawleys Island; Brian and Sassy Henry of the Sea View Inn; Ginny Horton and Carolyn Haar of *Island Magazine*; Doc and Martha Lachicotte; Alberta Lachicotte Quattlebaum; Rebecca Quattlebaum Blanton; Caroline Easley Alday and the Fraser-Easley family; Connie Bull; Anna Kate Hipp; Michael and Virginia Prevost; the Ellerbe and Marlow families; Avis Havel Hutchinson, John and Betty O'Brien; the families and executors of Mary Anne McCarley and James Fowler Cooper; and James Eaves, for the executors of Elizabeth White. Finally, thanks go to our spouses: Lee's husband Bill Shehan, a loving supporter of all her projects, and Steve's wife, Cokie Roberts, who agrees that coming to Pawleys was the second-best decision they ever made—only after getting married more than 51 years ago.

INTRODUCTION

Pawleys Island calls itself the "oldest seaside resort" in America. That might not be true, but one fact is indisputable: for 200 years or so, this sliver of sand on the South Carolina coast has been captivating visitors, creating memories, and celebrating the pleasures of doing, well, as little as possible. Pawleys is a refuge and a retreat, a special sacred place, separated from the mainland by a small creek and miles of attitude.

The island's quiet, compelling beauty—the sea and the sky, the sand dunes and salt marshes— has inspired generations of writers, including Elizabeth Allston Pringle, daughter of an early settler, R.F.W. Allston. She was born in her family's summerhouse at Pawleys in 1845, and in her memoir, *Chronicles of Chicora Wood*, she recalls her delight at returning each May during her childhood: "To me it has always been intoxicating, that first view each year of the waves rolling, rolling; and the smell of the sea, and the brilliant blue expanse; but then I was born there and it is like a renewal of birth."

By 1902, the island had grown considerably as a tourist destination and W.H. Wallace, editor of the *Newberry Observer*, filed this report: "Though it is almost out of the world, Pawleys just now is lively with many clever clever people here from various sections of the state, and everyone having a fine time. It is a free and easy sort of life, the conventionalities being laid aside for the time being. People don't put on airs down here—indeed they don't put on much of anything when they go into the surf, and that is the chief occupation here."

Published in 2005, Dorothea Benton Frank's novel *Pawleys Island* features a character who states, "I could stand on the porch and breathe in with all of my lungs, exhale my troubles in a whoosh, and the breezes carried them away. My shoulders dropped back to their natural position. I moved differently, slowly but with deliberateness. I slept soundly remembering all my dreams. That seemed to be the general consensus of everyone on Pawleys Island. It's a simple retreat for some and a spa to the soul to others. One thing is certain: it's unlike any other place in God's entire creation."

In three different centuries, these writers have all described Pawleys in a similar way. Eternal. Timeless. People play here. Relax here. Breathe here. Dream here. And they keep coming back, year after year, generation after generation. The authors have been visiting and living here for a combined total of almost 90 years, and as Steve Roberts and his wife, Cokie, once wrote, "When we first came to Pawleys Island . . . our kids were eight and 10. We'd watch them dash through the surf or dig in the sand and say to ourselves, someday we'll have grandchildren playing on this beach. And now it has happened."

This "spa to the soul" is less than four miles long and barely two streets wide in most places, separated from the mainland by a creek that's so narrow, you can wade across it at low tide. But when you reach the island, your shoulders really do drop "back to their natural position." Life is reduced to simple choices and simple pleasures. As Steve wrote in the *New York Times*, "relentless lassitude" is a Pawleys specialty: "A leisurely afternoon blends into evening the way

the sea meets the sky—almost imperceptibly—and the biggest decision to be made is what to read on the beach or eat for dinner."

Pawleys is a well-kept secret, bounded by two more popular tourist attractions: Myrtle Beach, 25 miles to the north, and Charleston, 70 miles to the south. In fact, when Steve wrote about the island, many locals were angry. "Don't tell all those outsiders about us," they complained. And even today, many people know only one thing about Pawleys: it is the home of the famous rope hammocks, first made and marketed here in the 1930s. Certainly a fitting symbol for a center of "relentless lassitude."

This place is far more than just a retreat or a spa, however. Its long and rich history is closely connected to a larger community, the Waccamaw Neck, a peninsula bounded on the west by the Waccamaw River, on the east by the Atlantic Ocean, and on the south by Winyah Bay, home to the colonial-era seaport of Georgetown. By 1710, colonists had established trading posts at Winyah and up the coastal rivers that feed into it. The English king began to make royal grants in the area, and the economy flourished because of two crops: indigo, used to make blue dye for military uniforms, and rice. Because the Waccamaw and other freshwater rivers—the Black, Pee Dee, and Sampit—flowed into the bay, they were subject to tidal action, and industrious planters harnessed those tides to flood their rice fields. By the mid-18th century, dozens of plantations had been carved out of the neck, each stretching several miles from the Waccamaw River to the sea.

The fetid rice fields brought disease along with prosperity, especially malaria, what one early account called "the summer sickliness of the plantations." The planters did not know that this deadly malady was spread by mosquitos, but they knew enough to send their families to the seaside for the summer. The first vacation colony in the area started on North Island, bordering Winyah Bay. In their book *Pawley's Island: A Living Legend*, Charlotte Kaminski Prevost and Effie Leland Wilder write that in June 1777, "three unexpected callers made their way at midnight" to a "lonely house" on North Island occupied by the family of a prominent planter, Maj. Benjamin Huger. One of the callers was the Marquis de Lafayette, later a hero of the American Revolution, whose ship was anchored in Winyah Bay. Writing a few days later to his wife, Lafayette praised the hospitality and character of the Americans he "first saw and judged . . . at Major Huger's house." The people he met were "as friendly as my enthusiasm had made me picture them. Simplicity of manners, willingness to oblige, love of country and of liberty, an easy equality prevail here."

That equality did not extend of course to the thousands of enslaved workers who made the plantation economy possible. Some household servants accompanied the planters' families on their seaside sojourns but there was a widely held belief that natives of Africa were immune to "the summer sickliness," and most slaves stayed behind on the plantations to continue working the land. In 1851, one survey put the population of Waccamaw Neck at 150 whites and "upwards of six thousand slaves."

When Pres. George Washington visited the area in April 1791, he noted in his diary that "we got dinner and fed our horses at a Mr. Pawley's, a private house, no public one being on the road." He spent the night at Brookgreen Plantation, which today forms part of a large artistic center and nature preserve, and arrived the next morning "at Captn. Wm. Alston's on the Waggamau [*sic*] for breakfast." He describes Alston, owner of Clifton Plantation, as "a Gentleman of large fortune and esteemed one of the neatest Rice planters in the State of So. Carolina and a proprietor of the most valuable ground for the culture of this article. His house which is large, new and elegantly furnished stands on a sand hill, high for the Country, with his Rice fields below." In 1819, another president, James Monroe, visited the area and stayed at the Huger estate, Prospect Hill. The rivers served as the main highways through the region and Lee Brockington writes in *Pawleys Island: Stories From the Porch* that Monroe "departed on a decorated barge with eight oarsmen, slaves dressed in livery."

North Island, where Lafayette was hosted by the Hugers, was exposed to fierce weather, however, and after a particularly brutal storm in 1822, the planters went looking for a safer spot to send

their families. They started building houses on what they called the "Canaan Seashore," the western side of the creek that separates Pawleys and an adjacent island, Magnolia, now called Litchfield, from the mainland. Pawleys Island itself was a wild place then, full of huge sand dunes and isolated by the creek. When the first houses were built on the island is a matter of some dispute, but a history commissioned by the Pawleys Island Civic Association concluded that "all of the historical evidence points to 1822 as the earliest date of construction on the island." Pawleys is named for the Pawley family, prominent landowners in the region dating back to the early 18th century, but there is no record of anyone with that name actually owning a house on the island.

Development of Pawleys began in earnest after 1842, when Col. Peter W. Fraser was granted 366 acres under an act aimed at developing "lands now vacant in this state." He started selling off parcels to families that had originally settled the Canaan Seashore on the mainland side of the creek. R.F.W. Allston, the future governor of South Carolina, made a major improvement in 1845, building what is today the south causeway across the creek that made travel to the island much easier. By 1848, Dr. Andrew Hasell wrote that Pawleys "contains many sites, upon nine of which houses have been erected, in which reside forty of the white population." One of those residents, Elizabeth Allston Pringle, writes fondly of "our summer home on Pawley's Island, which we always spoke of as 'the beach,' as though this were the only beach in the world." (The apostrophe in 'Pawley's Island' was dropped many years later by the post office.)

Many Pawleys loyalists still think of it as "the only beach in the world," and those who want bright lights and nightlife go elsewhere. As historian Charles E. Lee has written, "The right kind of newcomers sense the special Pawleys feeling and soon become old Pawleys families themselves. The honky-tonkers just don't come back." No, they do not, and this sense of tradition and continuity has always been part of Pawleys life. In *Stories From the Porch*, Roberta Prioleau recalls Sunday worship at All Saints: "After church, we visited our loved ones' graves and our own future gravesites." Sally Hamby, whose family started coming here in the 19th century, writes, "Things are slow to change here and even though we don't have a staff of servants, even though we don't sit on the front porch in stockings and corsets or shirt and necktie, we still maintain the old rhythms. We sing the old songs. The family life, for us, is the most important thing about Pawleys." Prevost and Wilder voice the hope "that Progress—so sought after in most places—will take a long look at Pawley's and fly on by."

Of course, some change is inevitable and even desirable. The nine houses that existed in 1848 have grown to about 500, and every scrap of vacant land is now being developed, including a large plot on the North End that once served as a pasture for the cows the early summer residents brought with them. "The first 'inside plumbing' on Pawley's was installed in the twenties when some homeowners invested in windmills placed over wells," writes Celina McGregor Vaughan in *Pawley's As It Was*. Electricity did not arrive until 1935, about the time the first bridge was built across Winyah Bay, connecting Pawleys to Georgetown and points south; the main road through the area, now Highway 17, was finally paved about the same time. For many years, the island embraced the sobriquet "Arrogantly Shabby," a phrase that appeared frequently on bumper stickers and T-shirts, and many of the older homes were proudly plain and rustic. Hurricane Hugo in 1989 destroyed many of those structures, and they have been replaced by much grander residences. Pawleys might still be arrogant, but there is nothing shabby about it.

There is nothing shabby about the Waccamaw Neck either. The end of slavery, storm damage to the fields and competition from other states ended the old rice-based economy by the early 20th century. Many of the plantations were bought up by rich northerners and turned into hunting and fishing preserves. One of the most notable was Hobcaw Barony, at the southern tip of the neck, where Wall Street financier Bernard Baruch entertained his friend Pres. Franklin D. Roosevelt for a month in 1944, about 153 years after the first president enjoyed the hospitality of the area's planters. Today, Hobcaw is preserved as a research reserve and outdoor laboratory. The holdings assembled by the Huntington family, heirs to a railroad and industrial fortune, include the Brookgreen sculpture garden and a state park. But what really changed

the economy and culture of the Waccamaw Neck was golf. The old plantations made perfect courses and a mild climate allowed year-round play. The premium rice grown here was known as Carolina gold. Carolina golf is just as lucrative today.

In 1985, island residents incorporated into a town for the main purpose of controlling growth. All commercial establishments were banned, and the ice-cream stands, bowling alleys, and dance halls that once flourished here have all disappeared. Pawleys remains an old-fashioned place, where the old rhythms still rule and the old songs are still sung. Elizabeth Pringle's beach, "the only beach in the world," is still here.

One

ORIGINS

In 1825, Robert Mills wrote about South Carolina's sea islands: "A happier situation is not to be found anywhere; for here the perpetual breezes and saline vapours are constantly rising from the ocean The good things of this life are here really enjoyed by the inhabitants in abundance; for the land and the ocean lay treasures at their feet."

The land and the ocean and its "saline vapours" are eternal, but two things turned Pawleys Island into a summer resort that still prospers almost 200 years after Mills's missive: rice and mosquitos. Planters grew wealthy cultivating rice along the region's coastal rivers, but they also produced bumper crops of disease-bearing mosquitos. The planters started sending their families to the seaside for the summer in the late 18th century, and Elizabeth Allston Pringle describes why in her memoir, *Chronicles of Chicora Wood*: "No white person could remain on the plantation without danger of the most virulent fever, always spoken of as 'country fever.' So the planters removed their families from their beautiful homes the last week in May, and they never returned until the first week in November, by which time cold weather had come and the danger of malarial fever gone."

From its earliest days, Pawleys provided visitors with the "good things of this life," from fresh shrimp to fiery sunsets, but the essence of its appeal has always been freedom. Elizabeth Pringle understood this as a young girl in the 1850s, when she rode her horse Rabbit on the beach every afternoon: "Those quiet rambles along the beautiful smooth beach, where nothing could hurt you . . . very soon became the greatest delight and joy to me." That is still true today.

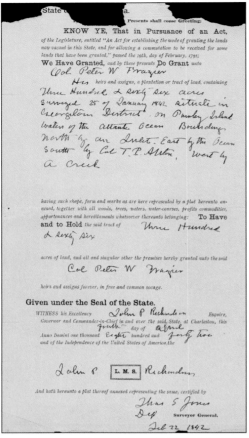

The modern history of Pawleys began in 1842 when Col. Peter W. Fraser was granted 366 acres on the island and started selling plots to his friends. This original deed shows his land bounded by three natural bodies of water—the ocean, the creek, and an inlet at the north end. To the south was property owned by Col. T.P. Alston. (Real Estate Indentures Collection.)

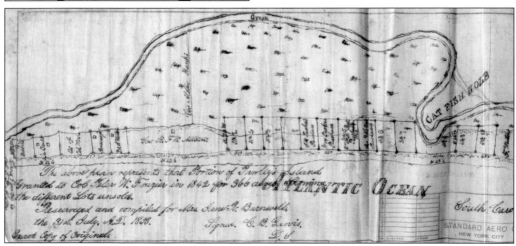

This survey in 1858 was done for Colonel Fraser's daughter Jane Barnwell, who inherited his property. By this time, about a dozen lots had been sold and developed, including the large one in the center owned by R.F.W. Allston, the father of Elizabeth Allston Pringle. He also built "Gov. Allston's Bank," the informal name for what is now the south causeway, the first bridge linking Pawleys to the mainland. (Pearce Collection.)

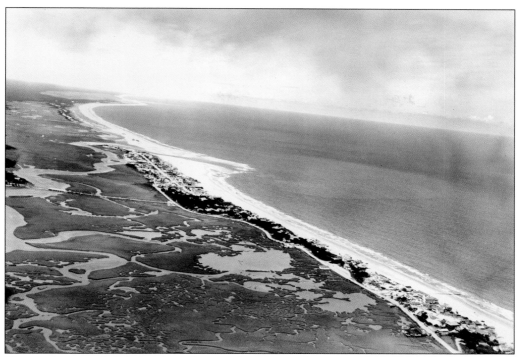

This modern aerial photograph, with a view looking north, gives a sense of what the early settlers encountered at Pawleys. This narrow strip of inhabitable land, wedged between the marsh and the sea, seems very fragile from this perspective. It took courage and imagination to see its possibilities and begin its settlement. (Walter S. McDonald Collection.)

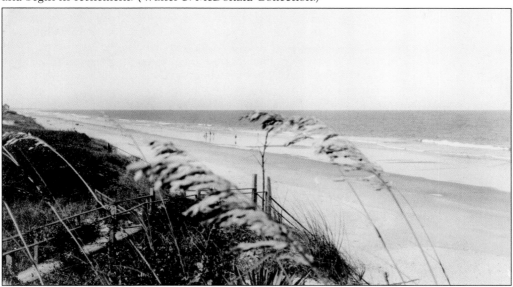

This is what the first settlers would have seen as they stood on the dunes and gazed at the ocean: the "beautiful smooth beach" on which the Allston girls loved to ride their horses. The distinctive plants, called sea oats, are the unofficial symbol of Pawleys and appear on everything from cocktail napkins and T-shirts to billboards and business logos. (GCL.)

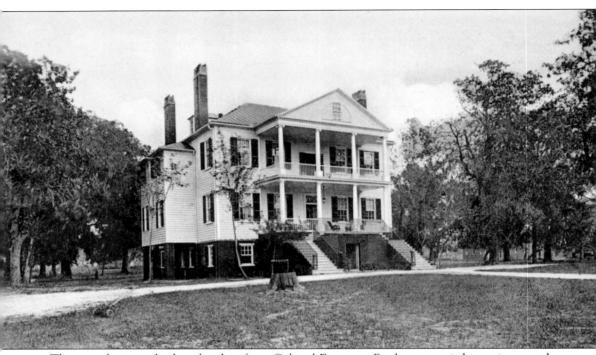

The rice planters who bought plots from Colonel Fraser on Pawleys occupied mansions on the area's inland rivers for six months a year, from November through April, and then moved their households to the seaside for the warmer months to escape the "country fever"—malaria. Elizabeth Pringle describes the annual migration as "this upheaval and earthquake" and adds, "It required so much thought, so many lists, so much actual labor. At the same time carpets, curtains and all the winter clothing had to be aired, sunned and put up with camphor against the moths." One of those winter mansions, Prospect Hill, was owned by the Huger and Ward families and entertained Pres. James Monroe in 1819. Like many of the old plantations, Prospect Hill was later sold to wealthy northerners who assembled vast hunting and fishing retreats in the area. This house, built around 1794, is owned today by descendants of the Vanderbilt family as part of a larger estate known as Arcadia. (GCL.)

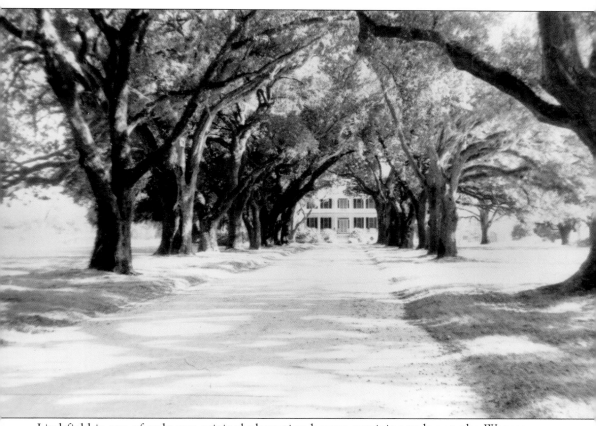

Litchfield is one of only two original plantation houses surviving today on the Waccamaw Neck. The distinctive "allee" of live oaks was a typical feature of those early estates. Litchfield was built around 1740 by Peter Simon, who gave the plantation its name and willed it to his two sons. Through most of the 19th century, the property was owned by three generations of the Tucker family, and one history notes that, by 1850, "Litchfield Plantation was producing one million pounds of rice per year." Litchfield was eventually bought and carefully restored by Dr. Henry Norris, one of the rich northerners who purchased plantation property in the early 20th century. In the 1960s, Litchfield was the first of the old plantations to be developed into a golf resort and residential community. The original house is used today as a wedding and events venue, and the name "Litchfield" is attached to several communities just north of Pawleys Island. (Waccamaw Council.)

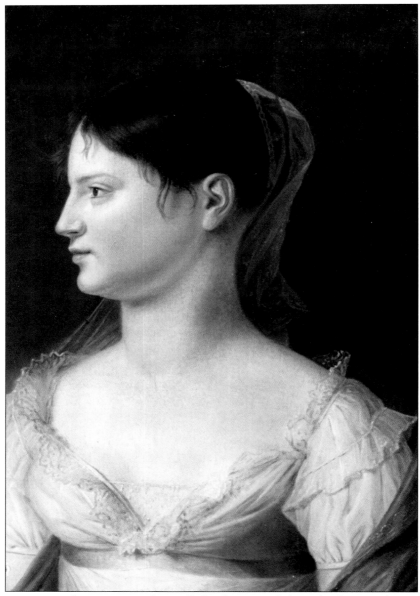

The Lowcountry, as this region is often called, vibrates with legends. One involves Theodosia Burr, the daughter of vice president Aaron Burr. She was married to Joseph Alston, the master of the Oaks, one of four plantations that today form Brookgreen Gardens. During the summer of 1812, the Alstons were staying at their summer home just south of Pawleys when their 10-year-old son, Aaron Burr Alston, took sick and died. "In her great grief," wrote Charlotte Prevost and Effie Wilder, "Theodosia longed to see her father." She boarded a schooner, the *Patriot*, bound for New York, but it never arrived. In one version of the legend, the vessel was seized by pirates, and Theodosia was forced to walk the plank. In another, she survived a shipwreck and lived to old age on the Outer Banks. The family always believed the *Patriot* sank in a storm, killing everyone aboard. Joseph Alston's grave at the Oaks, which can be visited today, speaks of the "aching void" his wife's death "left in his heart." (Brookgreen Gardens Collection.)

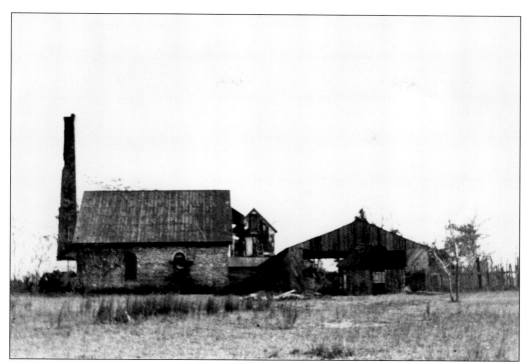

The large plantations that grew rice along the coastal rivers were also industrial operations, often milling their own products before shipping them downriver to the port of Georgetown. The above photograph, probably taken before 1875, shows the old rice mill at Barnyard Village, which today is part of Hobcaw Barony, the large estate assembled in 1905 by financier Bernard Baruch. The image at right shows the rice mill smokestack at Laurel Hill Plantation, constructed of locally made brick and typical of the region. During the Civil War, Confederate troops built earthen structures at Laurel Hill to block Union troops from infiltrating north along the Waccamaw River. (Above, Belle W. Baruch Foundation, Hobcaw Barony; right, Brookgreen Gardens Collection.)

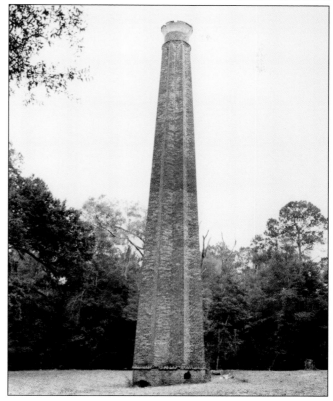

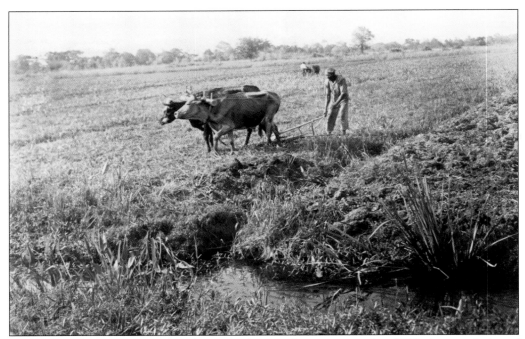

Enslaved workers were central to the rice culture and economy, and in 1850, the population of Georgetown County was estimated to be 85 percent black. The swamps and fields bordering the rivers were cleared by slaves and then cultivated by them, often using ox-drawn ploughs, like the one pictured here. (Brookgreen Gardens Collection.)

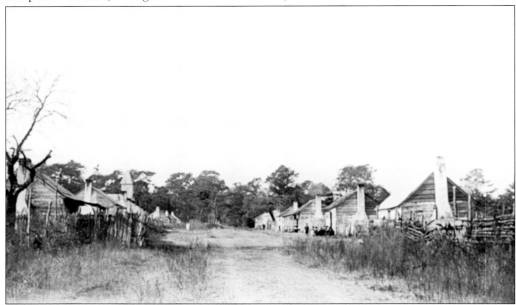

Most plantations on the Waccamaw Neck averaged 1,000 acres and 100 slaves who lived in villages along a street like this one, lined with about a dozen two-room cabins. The remnants of this village, originally part of the Friendfield Plantation, are preserved today on the grounds of the Hobcaw Barony. (Belle W. Baruch Foundation, Hobcaw Barony.)

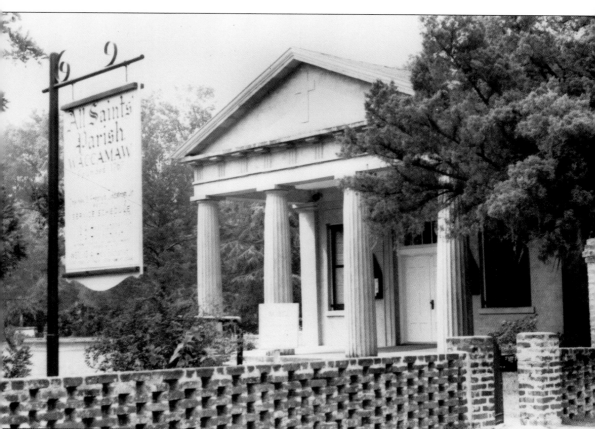

Early settlers of the Waccamaw Neck worshipped mainly at a church named All Saints, Waccamaw, Episcopal Church. The first congregation was formed in 1737 on land donated by Percival Pawley. The church sat on the shores of Chapel Creek, an offshoot of the Waccamaw, so planters and their families traveling by river could get there easily. All Saints became fully independent from the Prince George Winyah Parish in Georgetown in 1767, when it was formally established by an act of the colonial assembly. Four church buildings have stood on this site over the centuries and the latest one, pictured here, was completed in 1917. An Episcopal Committee's report from 1860 notes that prior to the Civil War All Saints Parish contained "more wealth than any other rural parish in South Carolina, or perhaps in the South." The church burial ground, dating from the 1820s, is noted for its collection of 19th-century graveyard art. The rectory building also dates from the 1820s. (Waccamaw Council.)

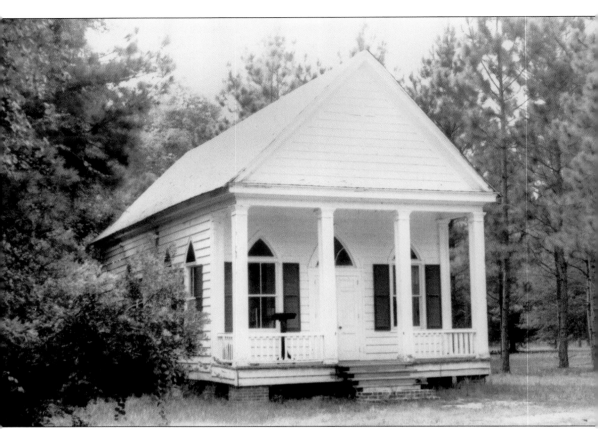

This building now on the grounds of All Saints was originally constructed in about 1850 as a chapel on the Cedar Grove plantation. It was one of 13 chapels built to encourage religious life among the area's enslaved workers and the only one that survives. The Rev. Alexander Glennie, who became rector of All Saints in 1832, toured these chapels every Sunday, conducting services and Bible classes and "often getting home after midnight," according to Prevost and Wilder. A visitor from the Middle West, Bishop Philander Chase, wrote home about Reverend Glennie in 1840: "The black children of a South Carolina planter know more of Christianity than thousands of white children in Illinois." For many years, the building housed extra services for summer visitors at the corner of Highway 17 and Waverly Road, near the north causeway to Pawleys. As commerce grew, the church sold that prime lot in 1976 and moved this chapel to the main church grounds. (Waccamaw Council.)

One of the earliest landowners on Pawleys Island was Robert Nesbit, a native of Scotland who owned a plantation he called Caledonia. This summerhouse stood on the island by 1842 and remained in the Nesbit family well into the 20th century. It is a good example of the early structures built by the rice planters and described by Celina McGregor Vaughan: "The original houses weren't mansions, but were built sturdily with enough rooms to accommodate big families. And they were always behind sand dunes for protection against the winds, rains and tides of a hurricane. The porches were on the southeast sides of the houses to catch the prevailing breeze, the ceilings high, the kitchens away from the main house and joined to the house by a breezeway." Since 1938, the house has been owned by the Norburn family of Asheville, North Carolina. (Tanya Ackerman Photography.)

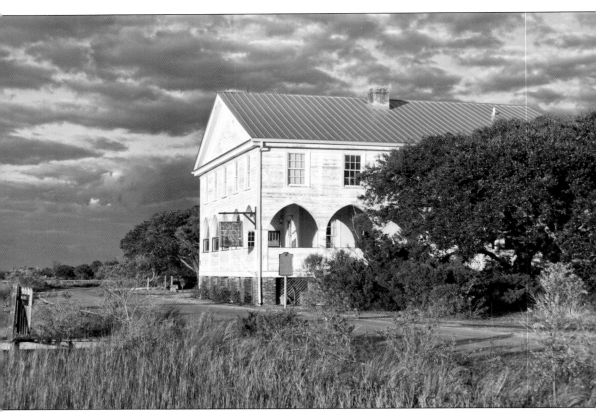

The most striking of the original houses sits high above the salt marsh and is known today as the Pelican Inn. It was built in about 1846 by the master of Hagley Plantation, P.C.J. Weston. An Englishwoman, Elizabeth Collins, who worked for the Westons, left a valuable diary that describes life on Pawleys during the Civil War, when Union gunboats were blockading Southern ports and she found herself "listening for the sounds of cannon which would now and then reach her ears." One night in the summer of 1863, she saw a Union vessel "trying to get into an inlet," and in a panic, "We at last concluded to pack up the silver and other valuables, in case the enemy made further progress, but no further firing was heard. . . . By the next day the enemy had disappeared." The next summer, Union vessels anchored "not more than six or eight miles out to sea," forcing the Westons to keep their upstairs windows closed. This "rendered the once delightful abode more like a gaol than dwelling," wrote Collins. (Tanya Ackerman Photography.)

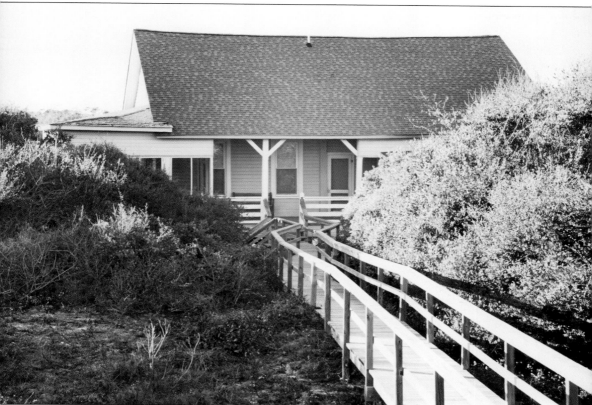

R.F.W. Allston, governor of South Carolina from 1856 to 1858, built one of the first houses on Pawleys. His daughter Elizabeth described it: "This dear old house consisted of *two* houses, each with two immense rooms down-stairs with very high ceilings and many windows and doors, and two rooms above equally large, but only half stories. . . . Both had wide piazzas around them which made a large, cool shady hall where they came together." The houses sat at right angles to each other, although only the structure facing the sea survives today. The household rose early, as Elizabeth wrote, "Oh! The delight of the freedom of the life on the seabeach after the city, and the happiness of being at home. The bathing in the glorious surf early in the morning—we often saw the sun rise while we were in the water . . . and had breakfast at what would now be thought an unearthly hour." After Hurricane Hugo struck in 1989, the old house was elevated on higher wooden posts. (Tanya Ackerman Photography.)

June, 11, 1927

Charles Petigru Allston
born July 31 - 1848 was
the youngest son of Robert F.W.
Allston & Adele Petigru his wife.
Born on Pawley's Island his
early years were spent at the
plantation, Chicora Wood &
the sea shore. When nine
years old, he was sent to
Mr. Porcher's school, Abbeville
District. War times coming
on, the boys diet was re-
-duced to squash & hominy.
Many a joke we heard
Papa & Cousin James Carson
make, at the recollection
of the meals.

This record was written by Susan Lowndes Allston 79 years after the birth of her father, Charles Petigru Allston, in 1848. Charles Allston was the younger brother of Elizabeth Allston Pringle, and like his sister, Charles was born while the family was spending the summer on Pawleys Island. Susan Allston writes that her father was sent away to school at age 9, and with the coming of the Civil War, the students' diet was "reduced to squash and hominy." Another impact of the war was felt at Pawleys Island, where the father of Charles and Elizabeth, R.F.W. Allston, had built large vats to capture salt from seawater. "Salt was a very scarce article at the time," Elizabeth writes in *Chronicles of Chicora Wood*, "and my father had it boiled from sea-water on the salt creeks of the Waccamaw seashore, behind Pawley's Island." Union gunboats stationed offshore would occasionally "throw a shell over the island," trying to damage the saltworks. "These interruptions became so frequent that finally the boiling had to be done at night," wrote Elizabeth. (GCL.)

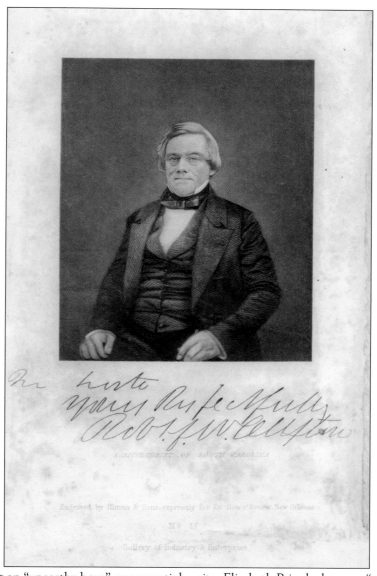

Getting up at an "unearthy hour" was essential, writes Elizabeth Pringle, because "my father did a tremendous day's work, which could only be accomplished by rising before the sun." On many summer days, R.F.W Allston would ride his horse after breakfast to the Waccamaw landing at Waverly and take a boat up the river to his plantations. He would spend the day inspecting his vast holdings and directing the work of hundreds of slaves before returning to the beach in the evening. R.F.W was a strong supporter of the Confederate cause and supplied rebel troops with two commodities they desperately needed: salt and rice. His daughter wrote, "He instituted and developed . . . the transporting of rice and salt up the rivers to the railroad. The ports, being blockaded, and no railroad within forty miles, it became necessary to make some outlet for the rice-crop to get to market and the army." Allston built two lighters, or decked-over barges, that hauled his crops northward, often through treacherous waterways, to railheads and supply depots controlled by Confederates. (Courtesy of South Caroliniana Library, University of South Carolina, Columbia.)

R.F.W. Allston was a particularly innovative figure in the development of Pawleys Island. Between January 1845 and November 1846, he constructed the first causeway linking the island to the mainland, which became known as "Gov. Allston's Bank." That causeway—the approach from the mainland is shown here—ended right at Allston's summer home. The mainland side ended on land belonging to the estate of Hannah Tait and threatened this small family graveyard. The agreement between Allston and Tait's heirs stipulated that in building the new bridge "the family burying place shall not be encroached on in any manner whatever." Allston kept his word, as the cemetery exists today. (Both, Tanya Ackerman Photography.)

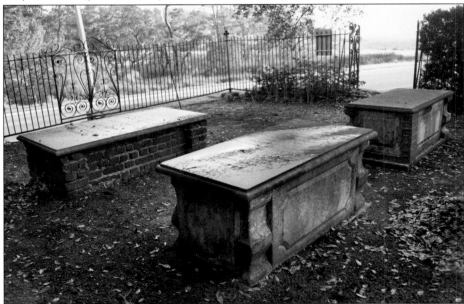

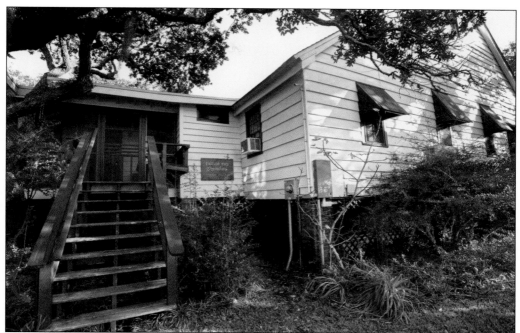

All Saints Church always had close ties to Pawleys. Peter Fraser, the original landowner, was the son of an All Saints rector, and in 1845, he gave the church a spacious lot. The church built this vacation residence for its pastor on the property, and for many years summer services were held in the house. In the 1940s, the Rev. Henry D. Bull, then the rector, wrote, "The comfortable old building nestling behind the sand dunes still serves the original purpose for which it was erected, having safely weathered all the storms of the ninety-odd-years." The house was sold to private owners in 1960, and the sweeping porch of the "comfortable old building" is populated today by typical Pawleys rocking chairs. (Both, Tanya Ackerman Photography.)

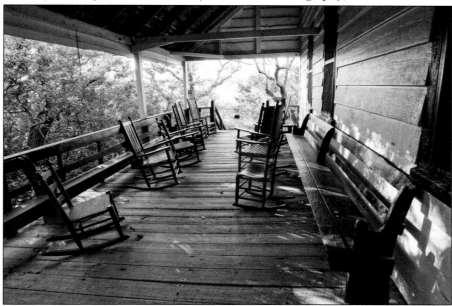

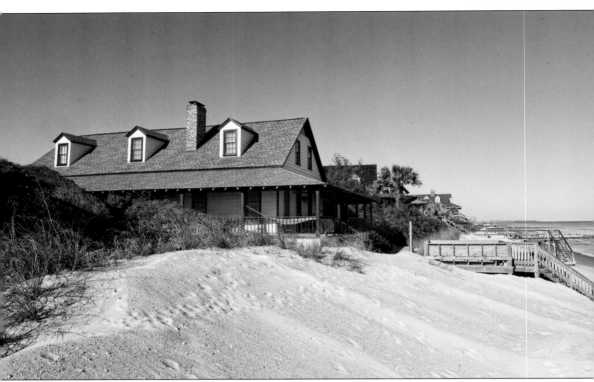

The All Saints Summer Academy is another example of the close ties between the church and the island. The academy was founded on the mainland in 1830 and relocated to Pawleys in 1848. In the late 19th and early 20th centuries, the house passed through several hands before Joseph Kaminski, a merchant in Georgetown, obtained it in 1918. Kaminski was part of a wealthy and influential family that gave its name to the Kaminski House museum that can be visited today on the Georgetown waterfront. Many Georgetown families vacationed on Pawleys, and Kaminski's daughter, Charlotte Prevost, owned the house for much of the 20th century and coauthored the valuable history *Pawleys Island . . . A Living Legend.* The house was badly damaged by Hurricane Hugo in 1989, and the building shown here is a significantly reconstructed version of the original. The sand in front of the house is piled there to impede beach erosion. (Tanya Ackerman Photography.)

This summer dwelling was built by John F. LaBruce, master of Oak Hill and Grove Hill plantations, who also ran an important saltworks north of Pawleys at what is today Murrells Inlet. Salt was an extremely precious commodity, central to preserving food, and LaBruce's operation was destroyed by Union troops during the Civil War. Notable features of this property include two small houses "which likely served as dwellings for slaves," according to *Pawleys Island Historically Speaking*. That is disputed by some historians who say the buildings were used to prepare food. What is not disputed is that slaves made possible the privileged and pampered lives the planters' families enjoyed on Pawleys. (Both, Tanya Ackerman Photography.)

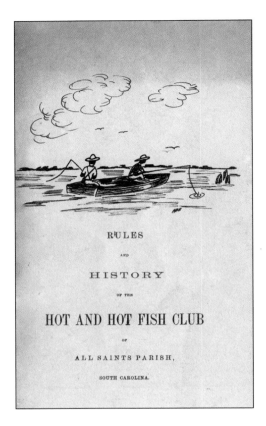

RULES

AND

HISTORY

OF THE

HOT AND HOT FISH CLUB

OF

ALL SAINTS PARISH,

SOUTH CAROLINA.

When the wealthy planters gathered at Pawleys for the summer, their principal social association was the Hot and Hot Fish Club. Their clubhouse was located on "Drunken Jack," a small island in Murrells Inlet, a few miles north of Pawleys, and on Fridays, the members launched small fishing boats into the inlet during the morning. "At one o'clock," recalled R.F.W. Allston, "the president . . . raised a flag to call in the boats; the fish taken by each boat was surveyed, and each variety in turn duly discussed. Sometimes the admiring crowd was enlightened by a narration of his capture." After dropping off their first catch for cleaning, some boats kept fishing, and this "second course" often produced the freshest and tastiest eating. Hence the club's name, "Hot and Hot." (GCM.)

REMINISCENCES

OF

EX-GOVERNOR R. F. W. ALLSTON.

My earliest knowledge of the Hot and Hot Fish Club was when, as a boy of fifteen, I went occasionally to the upper beach on a visit to my excellent and very dear sister (Elizabeth) Mrs. Tucker. Mr. John H. Tucker, a keen and successful sportsman all his life, was as ready for the fishing, when the day came round, as for a deer drive. There was no one, not even "big uncle," Jack Green,* to surpass him in deep-water fishing. I was always glad when my visit to his home included a club-day. I had a place and line in his boat,

* This venerable citizen lived on the sea shore summer and winter, and at very trifling expense; his table being supplied, and bountifully, besides the product of his well-stocked farm, with game from the forest, and fish and shell-fish from the salt-water creeks. Latterly he became too heavy and clumsy to venture far into the forest, but his man Joe and others brought in much game. In this connection, let it be noted, how admirably located are the inhabitants of Waccamaw Neck (some twenty-five miles in length) for commanding the bounties of nature. Besides the game which abounded, the noble river Waccamaw and its tributary creeks, furnished varieties of bream, perch and trout—whilst the products of the ocean and the salt-water creeks were easily obtained on the other side, within three or four miles. Mr. Green lived to a good old age. He stood six feet four inches in his shoes, and weighed some three hundred pounds. He gave up brandy-drinking entirely some years before his death.

Two

EARLY DAYS

The aftermath of the Civil War brought a new era to Pawleys Island. Some of the wealthy planters were now impoverished and had to sell their beach homes. Others opened their cottages to boarders to make ends meet. Steamboats ran regular schedules north from Georgetown up the Waccamaw River and dropped passengers at the Hagley and Waverly landings, a service that made getting to the island much easier. For the first time, a strange tribe of newcomers called "tourists" joined the old families in enjoying "the only beach in the world."

One of those early visitors, Matthew Tighe, wrote in 1888 that a trip to Georgetown "would be incomplete without taking a look at Pawley's Island, which is coming into some notoriety as a summer resort." These tourists were attracted by the same natural conditions as the first settlers, a wide flat beach "which slopes gradually from the sand hills out to any depth at sea," wrote Tighe. "Bathing on such a beach can scarcely be excelled anywhere."

Timber was replacing rice as the major commercial product of the Waccamaw Neck and the Atlantic Coast Lumber Company employed a large number of workers at its mills and wharves in Georgetown. The company bought the old Weston House, now the Pelican Inn, as a retreat for its workers, and in 1901, it constructed a railroad from the Hagley landing to the south causeway reducing the trip from boat to beach to a few minutes. The lumber company railroad lasted only five years—it was destroyed by storms in 1906 and never rebuilt—but it helped change the character of the island forever. Pawleys was now public.

Georgetown's *Sunday Outlook* for June 8, 1902, ran a headline, "Ho, For Pawleys Island," and added, "Georgetown's Famous Summer Resort Opens Up Today." So, 80 years after the first homes were built on the island by privileged rice planters, Pawleys was now "famous" and open for business. The article's author notes that he had been getting inquiries about tourist facilities from "the whole upcountry and even from other states," like North Carolina and Georgia. "With a certain amount of judicious advertising," he writes, "Pawleys Island could be made one of the most popular watering resorts in the South." Two Sundays later, the paper published another story, "Pawleys Island News," which reports that "considerable building is going on now which will make more room for increasing numbers to come during the next few weeks." (Both, GCL.)

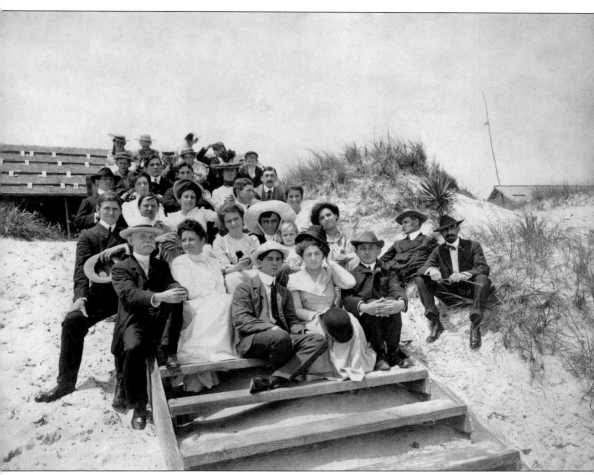

The *Sunday Outlook* of June 22, 1902, notes that "this season promises to be a gay one. Indeed there is no better place anywhere to be entertained properly." Barely two months later, this picture was taken on the Pawleys beach showing "the Strollers Club," a group of young people that included many friends from Georgetown. Their attire is pretty formal for a beach outing—suits and ties, stiff collars, and long skirts—but a touch of playfulness shows through. The men and women in the two lower ranks have exchanged hats, and one fellow is wearing a wide-brimmed bonnet tied below his neck. The *Outlook* had announced that "several dances are on foot to take place during the next few weeks," and these young people were probably gracing the dance floor that evening after strolling the sand during the day. (Morgan Trenholm Collection.)

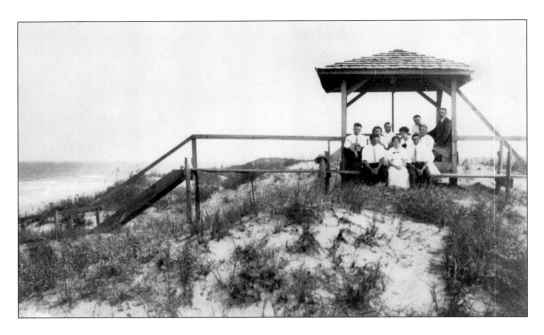

The original Pawleys houses were built behind the dunes for protection from storms. To get to the beach, residents built long wooden walkways across the sand hills, a style that is still popular today. These walkways are often embellished by structures, sometimes two stories high, containing benches, tables, and an occasional hammock. They are ideal for watching birds, taking naps, enjoying sunsets, and drinking cocktails. In the early 20th century, when the dunes were a lot higher than they are today, these structures were called "lookouts." These two photographs show the Ehrichs, a wealthy merchant family from Georgetown, posed on their lookout. Ehrich heirs still own the house called Liberty Lodge, one of the oldest on the island. (Both, GCM.)

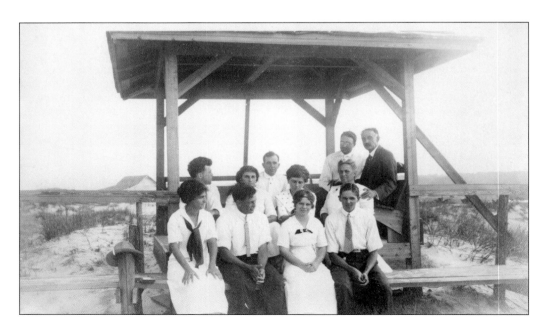

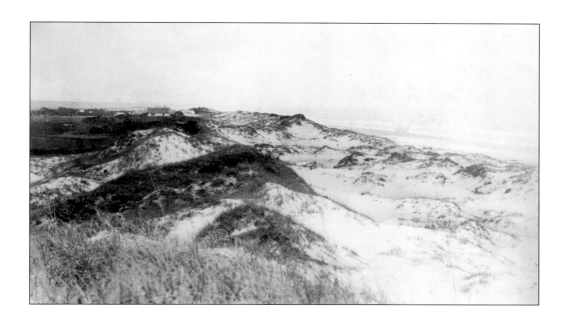

Pawleys was still an untamed place in the early 20th century, with huge dunes piled up behind the beach. The first houses built in the mid-19th century were clustered together in what is today the island's historic district, right along the marsh near the south causeway. By the early 20th century, these homes were being built in more isolated areas north of the early settlements and closer to the ocean. Below, a lonely lookout is perched high on a dune, with rather steep steps leading down from the sand hill to the beach. Today's lookouts are not as dramatic, since the dunes are not as high. (Both, GCM.)

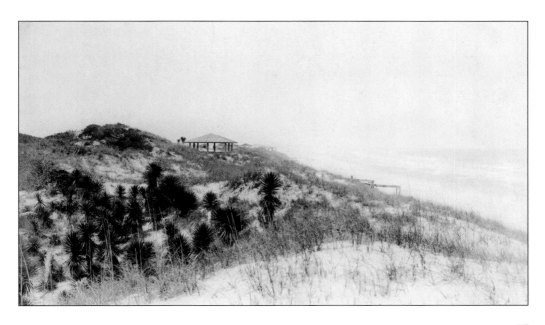

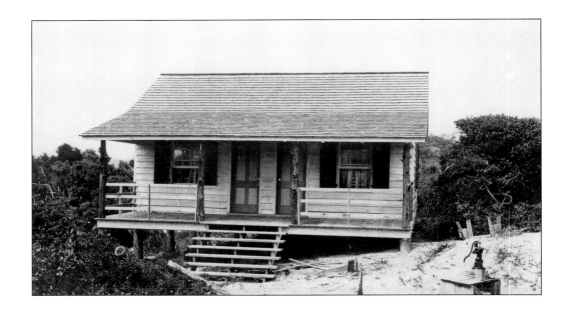

The "considerable building" heralded by the *Sunday Outlook* in 1902 produced cabins like the two pictured here. On the one above, the roofline is typical of old Pawleys houses, a peak covering the living area that breaks to a flatter angle to cover the porch. The house below has the same distinctive roofline but with dormers, indicating a second floor. Behind this house is a view of the marsh and the creek, and in the distance, homes are built on the mainland side of the creek, the "Canaan" shore, where the rice planters first settled this area. Rustic cottages like these gave Pawleys its old nickname—now quite outdated—of "arrogantly shabby." (Both, GCM.)

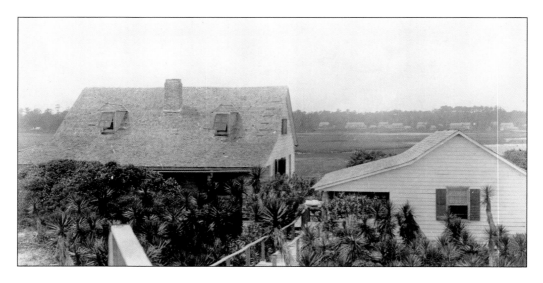

In September 1900, a white police officer in the port city of Georgetown was shot and killed by a black barber. "Tensions ran high," reads one history, "as a crowd of black supporters and a white lynch mob gathered at the jail." The governor sent in militias to keep the peace, and they set up this camp on Pawleys Island, seen in this view looking south to the island's tip. (GCM.)

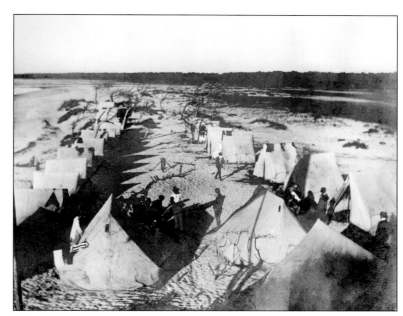

The outpost was informally named "Camp Jessie Butler" after the woman who ran a boardinghouse on Pawleys and allowed the troops to use her land. Butler is shown here with the camp commander. "The show of force and the willingness of the mayor to talk to all parties paid off," wrote the historian. "There was no violence." (GCM.)

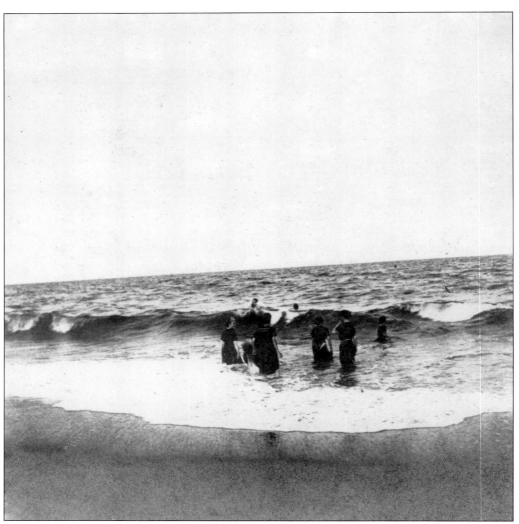

The early stories promoting tourism on Pawleys usually emphasize the pleasures, and the safety, of the beach. An article in the *Sunday Outlook* of June 1902 enthuses, "The surf bathing is not excelled on the Atlantic coast. Hard, smooth, gradually inclined bottom. No quick sand." Elizabeth Allston Pringle wrote a similar description about enjoying the beach a half century earlier: "My sister was a fearless horsewoman, and during the summers which we passed on this beautiful island, which had a splendid, hard, broad beach three miles long, she spent all her afternoons on horseback." The gentle slope of the beach attracted women as well as men. There are no pictures of the Allston girls riding their horses, but this one shows a group of about six women enjoying the surf. The original caption calls their costumes "obviously very cumbersome but not insurmountable." (Morgan Trenholm Collection.)

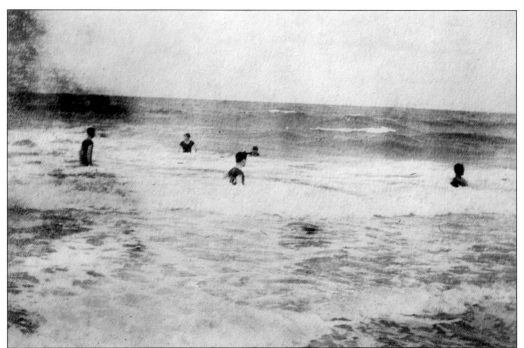

Swimming and splashing in the ocean, or just strolling barefoot along the surf, has always been a favorite Pawleys pastime. The gentleness of the waves, with few whitecaps, is noticeable in the above photograph. Below, a group of bathers poses at seaside, wearing typical swimming garb of the early 20th century. The women all wear caps, and even the men do not show much skin. One fellow, second from the right, seems to be wearing a primitive life preserver across his shoulders. The beach is so wide that even on popular summer holidays it seldom feels crowded. (Above, GCL; below, Kaminski Prevost Collection.)

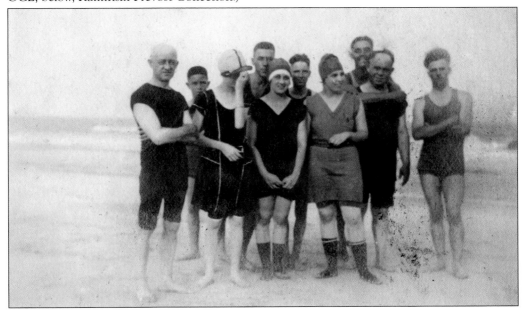

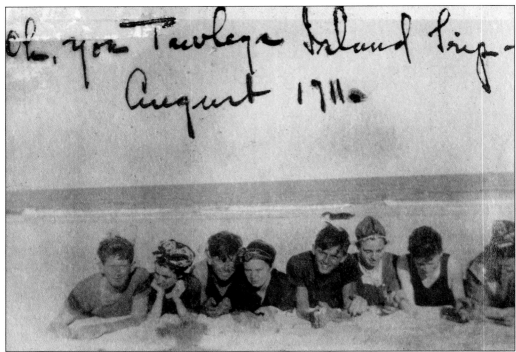

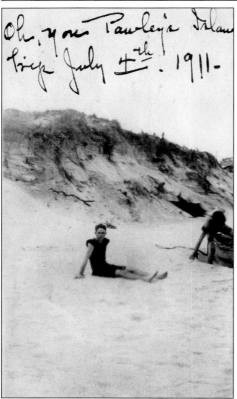

When folks go on vacation, they often take a lot of pictures, and then they write on them to remember the places and dates they enjoyed so much. These two photographs record holiday trips to Pawleys early in the 20th century when tourism was just developing. In the image above, four men and four women lie in the surf in August 1911. They might be on a day trip or renting rooms in a boardinghouse. The photograph at left was taken of two men in 1911 on July 4, a popular holiday at Pawleys that today still includes large house parties and an annual parade. (Both, GCM.)

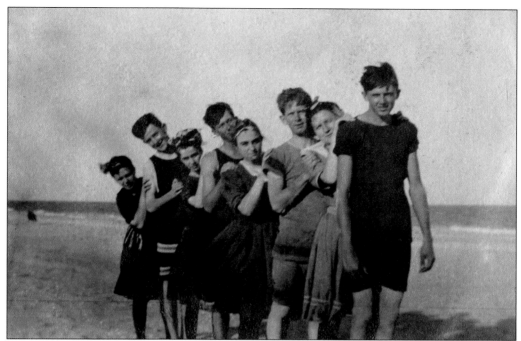

Groups have always come to Pawleys together, from the same high school or college, fraternity or sorority. Today, they could be golfing buddies, a prayer group, or a family reunion. The young people in the photograph above visited the island together in about 1910. The women's bathing costumes were still so modest that they feature billowing skirts, not ideal for water or beach sports. The island has also been a spot for young couples like this one to steal a romantic getaway. Search for "Pawleys" in the *New York Times* archives, and most of the entries report weddings conducted on the island. (Both, GCM.)

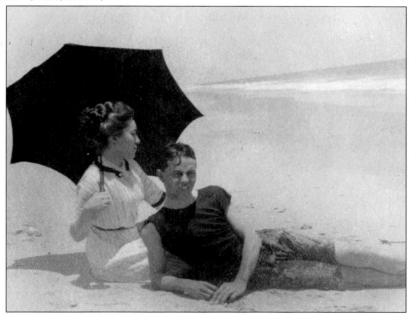

Pawleys has always been, above all, a family beach. The sand, especially at low tide, stretches hundreds of feet from dune to surf, and tide pools are created, making ideal playgrounds for young children. A typical scene on any sunny afternoon includes toddlers, some still in diapers, waddling down to the surf to fill their buckets with water and return to their construction projects. The three children at left pose with the sea behind them. It is a Pawleys tradition to bring even small babies to the beach and get them acclimated early. These two bonneted little ones are part of that long history. (Both, GCL.)

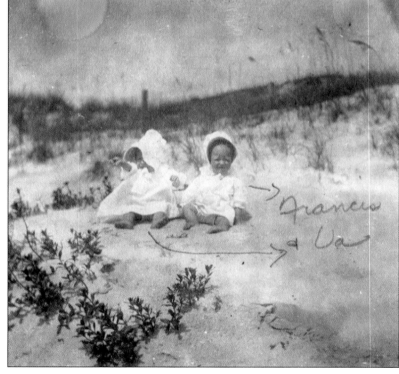

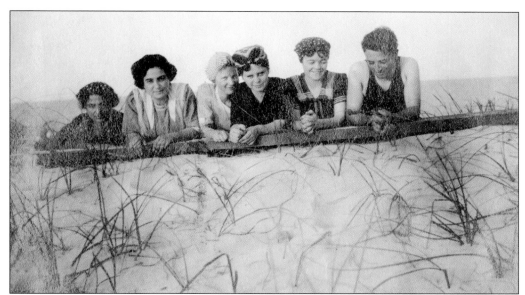

Family groups spanning many generations often occupy these old houses at the same time. Today's parents and grandparents visited the same houses and played on the same beach when they were small children. The group above, posing on the sand, could well be cousins. The two women at right are mother and daughter, members of the Lachicotte family that bought the Waverly plantation in 1871 but spent summers on Pawleys and created the famous Pawleys Island hammock. There is one on the porch behind them. Some houses have been in the same family for 100 years or more. (Above, GCM; right, Tarbox family collection.)

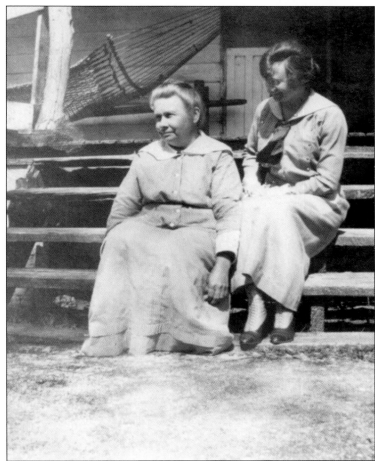

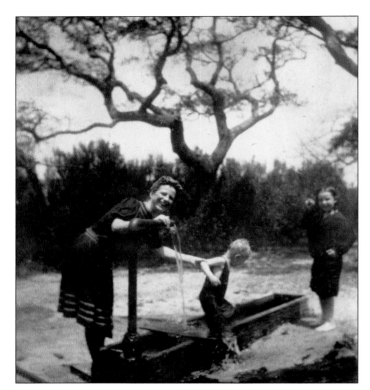

Fresh water was always a scarce commodity on the island. An article in the *Sunday Outlook* of June 8, 1902, promises visitors, "An important item on the beach is good water, and they have it in an excellent flow of several artesian wells." What the article does not say is that to enjoy that water, someone had to trek to the wells with large containers to haul it back home. This young woman seems to have solved that problem by bringing small children to one of the wells and giving them a bath right there. Celina Vaughan notes that some early settlers brought fresh water from their plantation wells "almost daily, in enormous demijohns." (Both, GCL.)

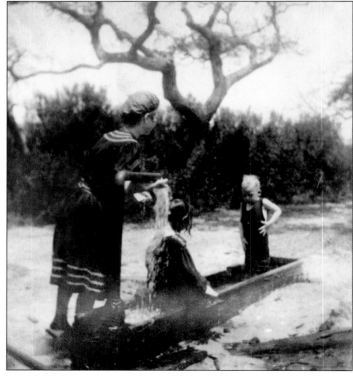

Boating has always been a popular pastime at Pawleys. Every creek-side house has a dock where small craft are moored. In older times, when commerce was permitted on the island, businesses working out of beach shacks rented boats. Today, those shacks are banned, so rental firms come to the beach every day with large trailers carrying dozens of canoes and kayaks. These two photographs dating from the early 20th century show a party departing from the beach in what appears to be a rowboat. The long skirts and long-sleeved blouses preserved female modesty but must have gotten awfully damp. (Both, GCL.)

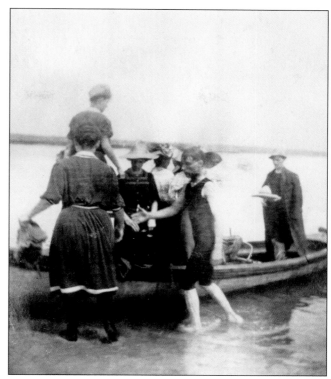

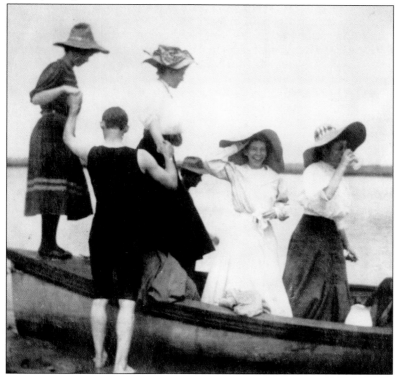

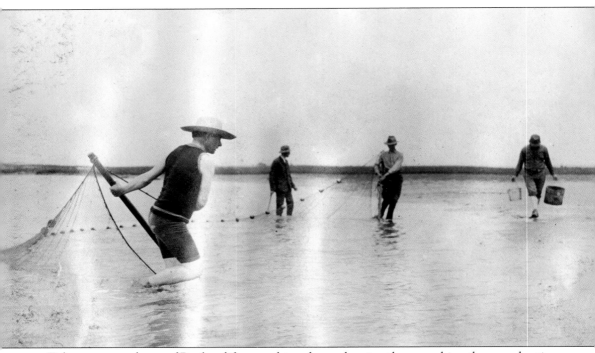

Fish are a central part of Pawleys life—catching them, cleaning them, cooking them, and eating them. In 1902, the *Sunday Outlook* promised, "There is no finer fishing grounds to be found anywhere. With a little perseverance and stickability you can catch all the fish you want." One favorite technique, especially in the early days, is depicted here: take a large net and drag it toward shore, dumping the catch on the beach. The men here seem to be sportfishermen, but commercial boaters and netters also worked the beach, and customers would crowd around and buy their catches for dinner. Celina Vaughan in *Pawley's . . . As It Was* points out that "fresh seafood was not always available upstate," because "proper refrigeration for perishable food was a problem almost everywhere." That was not a problem at Pawleys, where plentiful catches were available daily. (Kaminski Prevost Collection.)

Fishing was a sport enjoyed by all ages and genders. As Celina Vaughan writes, "The ladies sometimes joined these activities, but they especially enjoyed the respite from housekeeping, and they appreciated the inexpensive relaxation." These two women are completely covered with large hats and long skirts, but they still managed to haul in what looks like a small flounder. They were fishing from the north causeway, the bridge built in 1904 to speed traffic to the island. The causeway crosses the creek, an especially rich source of flounder, and it is still crowded with fisherfolk today. (Both, Morgan Trenholm Collection.)

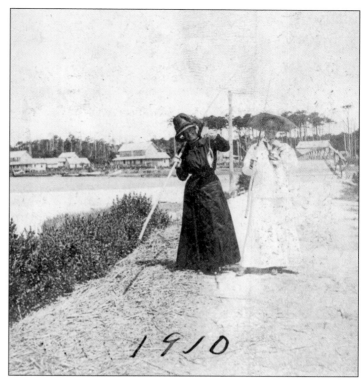

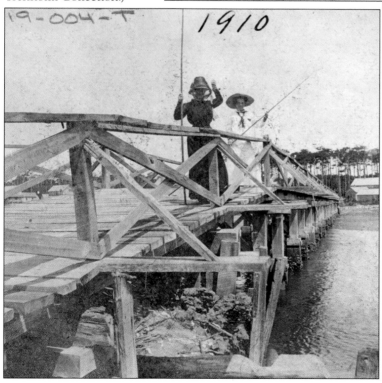

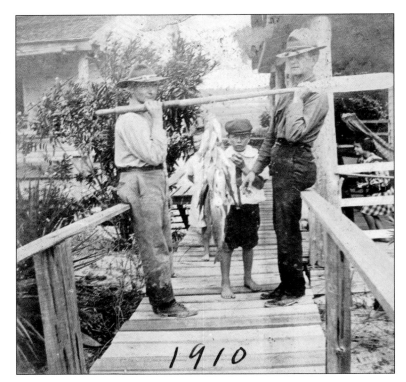

Two men and a small boy show off their catch. Surf-fishing was then, and still is, a popular pastime, particularly in the evening. Some fishermen rowed small boats out beyond the surf line, and since these men display their catch on a paddle, perhaps that's how they made such a hefty haul. (Morgan Trenholm Collection.)

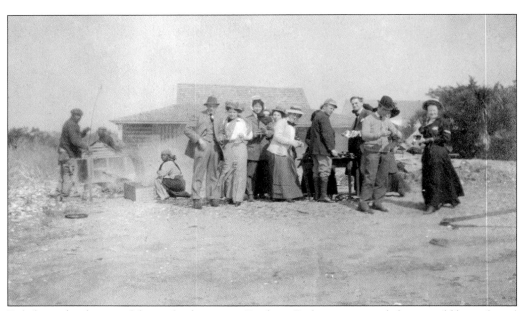

Fish formed only part of the seafood menu on Pawleys. Crabs, oysters, and clams could be gathered from the creek, and freshly caught shrimp was widely available. One small entrepreneur parks his truck at the north causeway today and sells his daily catch of shrimp out of a cooler. Oyster roasts like this one were popular ways of eating and socializing. (Ehrich-Bull collection.)

Turtle eggs were another favorite delicacy during the early days of island tourism. Celina Vaughan quotes one pioneering visitor, "Sometimes when we went on the beach in the early morning we would find turtle tracks and discover a nest of turtle eggs buried in the sand. This was a gourmet treat for adults—turtle eggs for breakfast. . . . They looked like ping pong balls . . . they were boiled and eaten by breaking the shell and sucking the yellow out . . . the yellow wouldn't harden when boiled." A group of men gather around a mound of turtle eggs they have just unearthed. These careless practices helped endanger the loggerhead turtles that come from the sea to lay their eggs at Pawleys. Today, volunteers patrol the beaches during egg-laying season and make sure turtle breeding grounds are fenced off to protect nests from predators, including the human variety. (Kaminski Prevost Collection.)

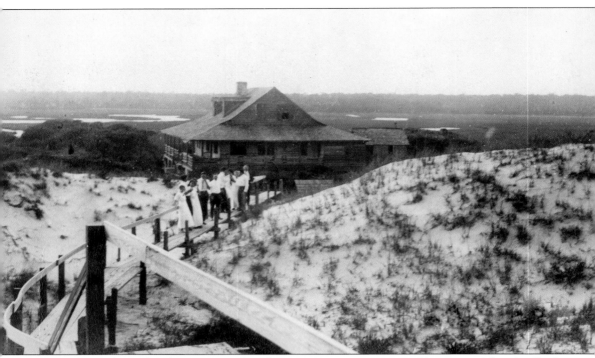

Two forces drove the change on Pawleys from a private retreat to a public resort. After the Civil War, families needed extra income to keep up their vacation homes. And as the island's reputation spread, tourists needed places to stay. Many homeowners rented out spare rooms, including two brothers, St. Julian and Frank Lachicotte, who lived next to each other, and as Celina Vaughan recalls, "One of the happiest memories of that era was the custom, in both homes, of the maids' serving delicious hot ginger bread among the guests at midmorning." One early island home was used as a summer residence by the rector of All Saints, and "in the hard times following the Confederate War when all other resources failed, the sole income of the church for several years was gained from the rent of this home in the summer," writes one historian. This house, owned by the Butler family and nestled in the dunes, was one of the first boardinghouses on the island. (Ehrich-Bull collection.)

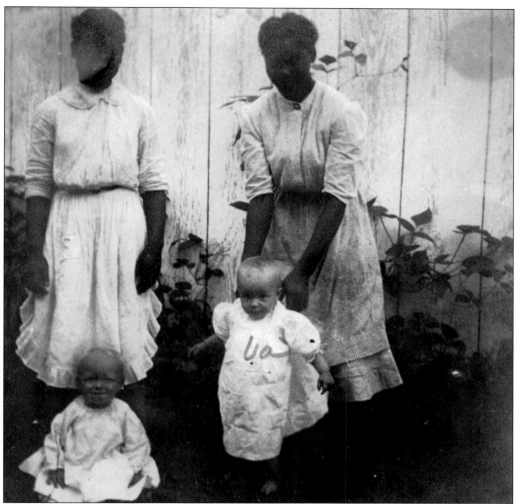

It was common for families to bring African American servants with them to the beach. Some of those servants were descended from slaves who had originally worked on the local plantations. These two young women served as nurses to small children; other blacks were cooks, handymen and "creek boys" who scoured the marshes for daily supplies of crabs, clams, and oysters. Historian Charles E. Lee writes, "Our cook, 'Two-Ma (great-grandmother) Sue' was the best on the island. She spoke pure Gullah—at least she spoke no English that either we children or the adults could understand. But we understood her cooking, all right. More than a hundred times since, I'm sure, I've tried to duplicate her Shrimp Pie, with no success." According to the *Encyclopædia Brittanica*, the Gullah dialect Lee mentions "developed in rice fields during the 18th century as a result of contact between colonial varieties of English and the languages of African slaves." (GCL.)

The early Pawleys houses had no air-conditioning of course, so folks gathered on the wide porches that surround most houses to catch a breeze. Porches are central to the Pawleys lifestyle, and this one, like so many others, is festooned with rocking chairs and of course a hammock. All that is missing is a pitcher of sweet tea. (GCM.)

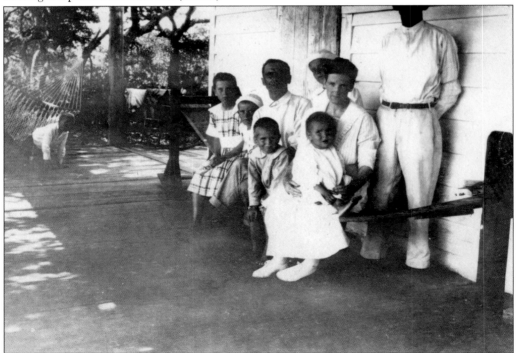

Another common feature of old Pawleys porches was a joggling board, a favorite of children and caretakers of cranky babies. The main board is usually between 10 and 16 feet long and made of flexible yellow pine. The ends are on rockers, allowing users to bounce on it or simply sway gently. (Tarbox family collection.)

Hammocks are not confined to porches, nor are they used only for solitary afternoon naps (although that is their highest and best use). These three young women enjoy a hammock strung outside, on a convenient tree. Behind them are a swing, a dog, and a view of the water, perhaps Pawleys creek. (GCL.)

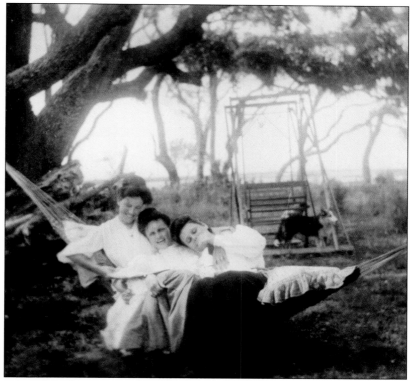

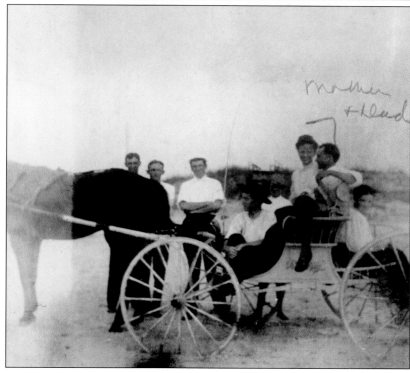

Animals were a central part of Pawleys life in the early days. Summer visitors brought their livestock to graze on the vacant north end, and they were a primary source of both food and transportation. Here, a group of young people gathers around a horse-drawn cart on the beach. (GCL.)

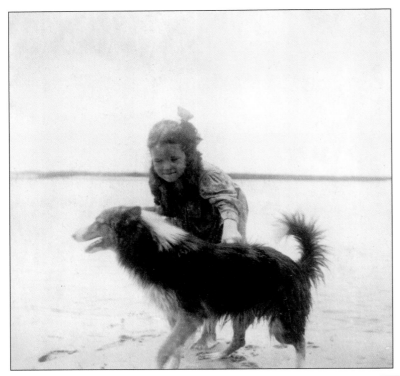

Dogs love the beach at Pawleys as much as people do—maybe more. Modern leash laws have curbed some of their freedom, but early in the morning or late in the afternoon, the strand has always been heavily populated by dogs of all kinds, like this one with a young girl in tow. (GCL.)

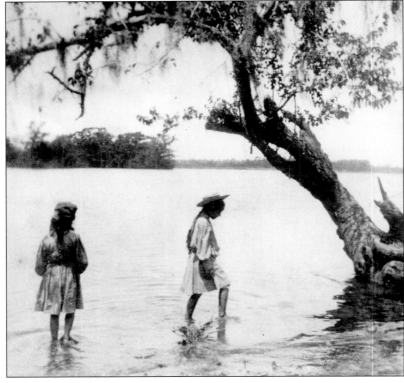

This iconic photograph captures the barefoot lifestyle that envelops travelers to this area. These girls seem to be wading in a river, probably the Waccamaw, perhaps at the Hagley Landing, where steamships from Georgetown delivered passengers bound for Pawleys. The arching tree artfully frames the girl in white and the angle of her sailor's hat. (GCL.)

54

Three

GETTING THERE

As the rice-planting culture developed along the rivers of coastal Carolina, transportation was mainly by boat. Goods and travelers were ferried to the closest landing, where horse-drawn carts—and later, rudimentary automobiles—took over to complete the journey over muddy rut-filled tracks. Elizabeth Pringle has left a vivid description of her family's annual trek from their plantation, Chicora Wood, on the Pee Dee River to the seaside. And since they were moving for six months, there was a lot to pack.

"The vehicles, horses, cows, furniture, bedding, trunks, provisions were all put into great flats, some sixty by twenty feet, others even larger, at first dawn, and sent ahead," she writes. The family then boarded rowboats, powered by "six splendid oarsmen, who sang from the moment the boat got well underway. Oh, there is nothing like the rhythm and swing of those boat songs. . . . I am filled with longing when I think of them." The party landed at Waverly Plantation on the Waccamaw, where "they found the horses all ready saddled, and they mounted and rode the four miles to 'Canaan,' where they were to spend the summer."

Well into the 20th century, most travelers to Pawleys made similar journeys, although they did not have slaves to row their boats or saddle their horses. They took a steamboat north from Georgetown or south from Conway, and after landing at Hagley or Waverly, they then had to cross those overland miles from the river to the sea. One early vacationer says the boat was greeted by various vehicles, such as horse-drawn wagons, hacks, and early-model Fords: "The ride over the sandy narrow road . . . seemed endless, the only relief being that this was the appointed time for children to take off their shoes and socks. The first whiff of salt air, at the approach to the causeway, exhilarated the weary but happy travelers."

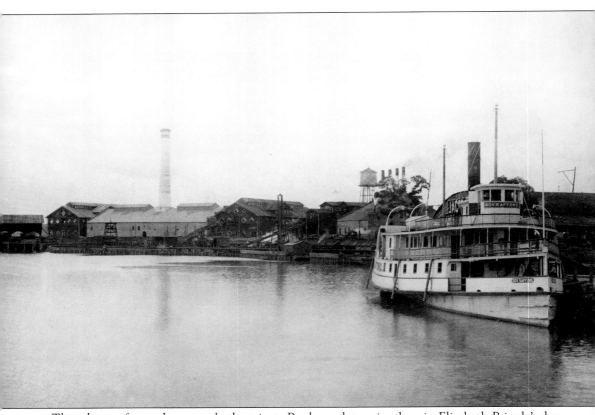

The advent of steamboats made the trip to Pawleys a lot easier than in Elizabeth Pringle's day, but it was still an arduous journey. Prevost and Wilder quote a Georgetown resident whose family migrated every spring to Pawleys: "When the day for the move finally arrived, the whole household was up and stirring at dawn. Food had been prepared: red rice and ham. The chickens and ducks were caught and put in their portable coops, the cat in her special cage, the goat was hitched to its wagon and the cow followed the horse and buggy." All this baggage was loaded onto boats like the *Gov. Safford*, docked here behind Front Street in Georgetown. The town's industrial plants, with smokestacks belching, are visible in the background. The ship's schedule was such big news that the *Sunday Outlook* for June 8, 1902, topped its main story with this announcement: "The steamer Gov. Safford makes her first trip to Pawleys Island today." (Morgan Trenholm Collection.)

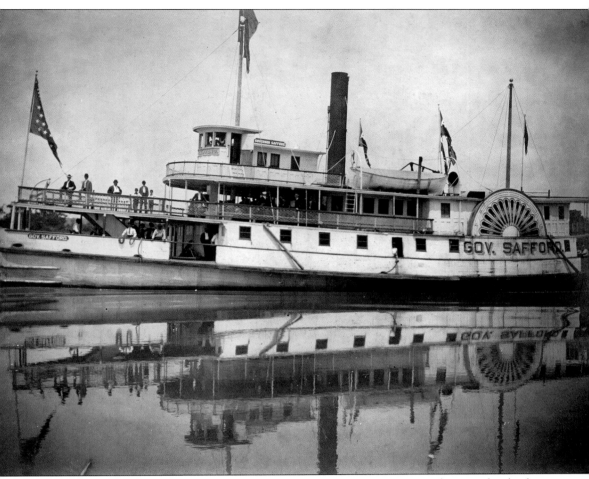

Here, the *Gov. Safford* heads out of Winyah Bay toward the Waccamaw River. This is a side-wheeler, a design typical of the age for river-going vessels. One traveler describes the "great excitement when the entourage arrived at the dock" and loaded its household goods, livestock included, onto the steamer. "These vessels went up the Waccamaw River stopping at Hagley and Waverly landings to deliver mail and freight. Children especially enjoyed the boat trip, as there was plenty of deck space to run and play on, and interesting sights on the river banks. Several families usually arranged to move on the same day, so that every child had someone his own age to play or talk with. At the first sight of the final landing, there was chaos and bedlam as the parents started gathering up their progeny and belongings for the disembarkment." (GCL.)

The river was a crowded highway with many smaller boats in constant motion, including the *Comanche* that made regular runs carrying mail, freight, and passengers. "The plantation owners at this time had their own smaller boats because it was important for them to get back and forth to the county seat more often than the large boats allowed," writes Celina Vaughan. These small craft, like the one tied up at Hagley, "made a certain rhythm as they traveled the Waccamaw River, and natives could hear the motors and know, without seeing it, which boat it was." (Left, GCM; below, Ehrich-Bull collection.)

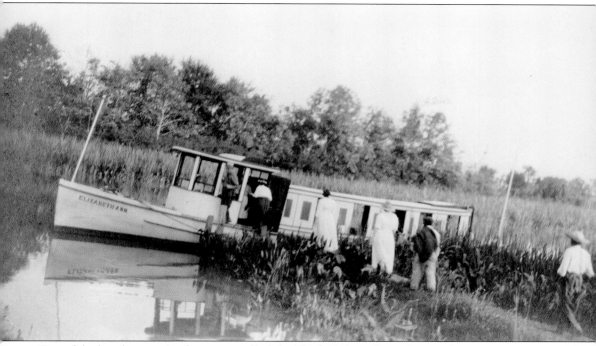

One of the best-known riverboats was called the *Elizabeth Ann*, shown here picking up passengers at a river landing. It was owned by Celina Vaughan's "Uncle Phil" Lachicotte and run by his African American engineer, Jim Sherman. She writes, "Among my fondest memories are the excursions they would take us on. Picnic baskets would be packed, and we would get on the boat at Waverly to ride to Baruch's Hobcaw Barony or the Pringle's Chicora Wood, or visit the LaBruces at Arundel." By 1924, the *Elizabeth Ann* had become a commercial carrier, ferrying passengers and small cargo up and down the river. A one-way trip to Georgetown cost 75¢; a round-trip, $1.25. Eventually, the market for these riverboats dried up as ferries started carrying cars across the Waccamaw at Georgetown and better roads made driving a bit easier. (GCM.)

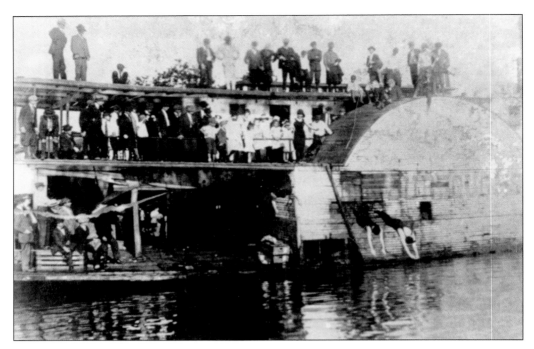

A real workhorse on the river was called the *F.G. Burroughs*. In the days before ferry service crossed the Waccamaw at Georgetown, the *Burroughs* was particularly important because it was the only steamer big enough to carry a car. As Celina Vaughan writes, "It was possible to travel by automobile to Georgetown, but arrangements had to be made weeks ahead of the Georgetown arrival in order for the 'The Burroughs' to reserve space in its hold for the car. . . . Another hardship involved was the time of the tides because it had to buoy the boat to the dock level in order to drive or push the vehicle off the pier to the boat or onto the pier from the boat." (Above, GCM; below, A.H. "Doc" Lachicotte Jr. collection.)

The rivers were a huge boon to many travelers but an obstacle to others. Ferries first started carrying passengers across the bays and rivers in the mid-18th century, and the ones pictured here were part of a vast network throughout the Waccamaw Neck. "So important were these ferries to travelers that they were controlled as a public service by the Commons House of Assembly," wrote Prevost and Wilder. Many of these smaller ferries were powered by hand, either poled across the water or pulled by ropes. The workmen were often African American in a county that remained heavily black long after the Civil War. (Above, A.H. "Doc" Lachicotte Jr. collection; below, GCM.)

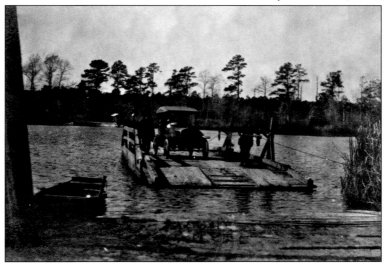

The coming of the steamboat did not end the use of muscle-powered boats, and every Pawleys house that fronts on the creek and marshland has a dock and a boat—and in many cases, several. These small craft were often used for fishing in the creek, where trolling slowly for flounder has long been a favorite sport and still is today. Bird-watching from a small boat is another popular pastime in the creek, which abounds with egrets, herons, and other winged creatures, and kayaks and paddleboards have joined the ranks of popular creek craft. This undated photograph frames a lone boatman heading through the marsh with a number of small craft pulled up on the shore. (GCM.)

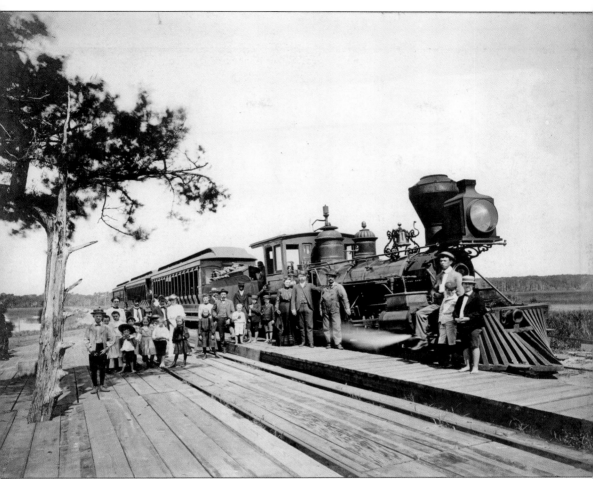

The *Gov. Safford* was described by the *Sunday Outlook* as "an elegant excursion boat, capable of carrying 800 people, and is very fast—making the trip to Hagley in 55 minutes." But the trip across three or four miles of bad road from Hagley to Pawleys Island was anything but fast. After the Atlantic Coast Lumber Company was founded in the 1890s, it wanted to make it easier for its employees to vacation on Pawleys—and get back to work by Monday morning. The company bought several properties on the island to house its workers, including what is today the Pelican Inn, and built a railway from Hagley to a station just east of the south causeway. It operated for only five years, however, making its last trip in September 1905. The tracks across the creek were destroyed by a hurricane in early 1906 and never rebuilt. (Morgan Trenholm Collection.)

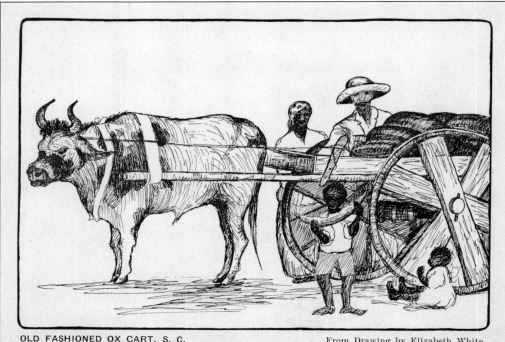

OLD FASHIONED OX CART, S. C. From Drawing by Elizabeth White

"They will arrive in their appointed hour unhurried by the goad of lesser wills."—*DuBose Heyward*

In the early 1900s, animal-powered transportation was still a central feature of island life. Families came for months and brought their livestock with them. A half century after Elizabeth Pringle raced her pony Rabbit along the beach, a wide variety of carts and contraptions, like the oxcart in this drawing by Elizabeth White, moved people and goods on a daily basis. The south causeway was constructed over a narrow section of the creek in 1845. The north causeway, in this drawing by James Fowler Cooper, was built in 1904 and bridged a much larger section. On the mainland, it connected directly to the primary east–west road that led to Waverly Mills on the Waccamaw. (Both, Alberta Lachicotte Quattlebaum collection.)

The building of the north causeway in 1904 foreshadowed the beginning of the automobile age—the Ford Model T debuted four years later—and by the 1920s, maps like this one were highlighting seaside attractions for motorists along the Atlantic coast, including South Carolina's Lowcountry. Pawleys does not make the map, however, and getting to the island by car in those days was still very difficult. Celina Vaughan describes an early car trip over poorly marked roads from Columbia to Conway—and completely anonymous tracks from Conway to the beach. "Any two ruts selected in the vein-like network of sand or mud was pure guess," she writes. "One could ride for hours it seemed, deadly weary from the earlier part of the journey, without seeing any sign of human life and just hoping he was headed in the right direction." (GCL.)

Early memoirs of driving to Pawleys all sound the same theme: it was awful. Dontine Sligh of Darlington, South Carolina, wrote to the *Charlotte Observer*, "After we left Socastee we left civilization, traveling through pine forests on a small winding sandy road. Sometimes when we came upon a puddle, the children would have to get out and wade through it to test the depth." (Connie Bull.)

In the 1920s, a ferry service was started across the river from Georgetown to the Alderly plantation. Two elderly ferries, the *Cornwallis* and the *Pelican*, made regular runs as this schedule from 1932 attests—at least officially. But as Celina Vaughan writes, "The boats weren't new when purchased and they gradually became unreliable." (GCM.)

GEORGETOWN, S. C., FRIDAY, SEPTEMBER 9, 1932.

Georgetown-Waccamaw
FERRY
WINTER SCHEDULE

(Georgetown, Pawley Island and Myrtle Beach.)

Lv. Georgetown—6.00; 7.00; 8.30; 9.30; 10.30; 11.30 A. M.; 1.00; 2.30; 3.30; 4.30; 5.30; 7.00; 8.30; 10.00 P. M.

Lv. Alderly—6.30; 8.00; 9.00; 10.00; 11.00 A. M.; 12.00; M.; 1.30; 3.00; 4.00; 5.00; 6.00; 7.30; 9.00; 10.30 P. M.

This Schedule Effective Monday, September 5, 1932.

(Subject to change without notice.)

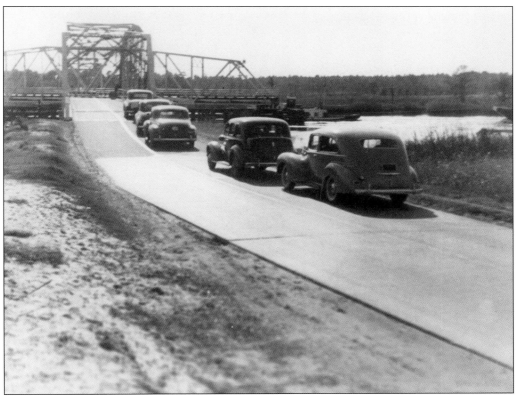

Driving to and through the Lowcountry improved considerably as bridges gradually replaced ferries across the area's many rivers. Cars line up to cross a river on a swing bridge, which opened regularly to allow river traffic to pass through. Early travelers complained of long waits, as the bridges were low and had to open even for small boats. Moreover, the bridges often stuck in an open position, further snarling traffic and stressing the patience of drivers. This bridge was probably close to Georgetown, perhaps on the Sampit River, as a large industrial smokestack belches in the background. (Both, GCM.)

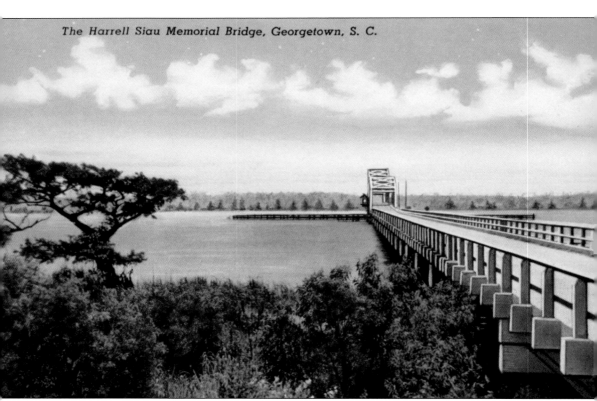

The Harrell Siau Memorial Bridge, Georgetown, S. C.

After the rice culture collapsed, Georgetown County went from being one of the richest counties in America to one of the poorest, and one reason is because the Seashore Road, now Highway 17, ended at the Waccamaw River as it fed into Winyah Bay. The two ferries, the *Cornwallis* and the *Pelican*, that carried cars across the river held only seven vehicles at a time and stopped running entirely in foggy weather. Doc Lachicotte says that when he was about to be born in 1926, his mother feared that the ferries would be grounded when she tried to get to the hospital in Georgetown. Life changed for the whole region in 1935, when this bridge was opened in a grand ceremony featuring the Marine Corps band from Parris Island. The bridge was originally named for Lafayette, who landed at Winyah Bay in 1777, but the name was changed two years later to honor Harrell Siau, a local dignitary. (GCL.)

Four

LIFE AFTER THE CIVIL WAR

After the Civil War, as Pawleys Island gradually developed into a tourist destination, life on the inland rice plantations was changing dramatically. "The loss of slave labor was difficult to overcome because rice was such a labor-intensive crop, grown in difficult and unpleasant conditions," writes Lee Brockington in *Stories From the Porch.* Competition from western states such as Louisiana and Arkansas drove the price of rice down. "And a series of storms between 1893 and 1911 destroyed rice crops in the fields, and the system of dikes and trunk docks were difficult to rebuild." In 1911, the last crop of rice was milled commercially in Georgetown County at Waverly Plantation.

"The post-war years were ones of extreme poverty" for many residents of the Waccamaw Neck, writes Brockington. In 1894, Pres. Grover Cleveland visited the area to hunt ducks around Winyah Bay and, at one point, got stuck in the muddy marshes. "The next day national newspapers carried the story of the president's 'near drowning,' " but the result was to draw attention to the area's enormously abundant fish and wildlife. "Curiosity brought duck hunters from New York, Delaware, Maryland and Virginia. These wealthy Northerners also found turkey, deer, quail, dove, feral hog and fine weather."

With the decline of the rice culture, the plantations lost their economic basis. Land was cheap, and the Northerners had plenty of money. The first "rich Yankee" to buy up property in the area was the Wall Street financier Bernard Baruch, who was a native of South Carolina and had visited the area as a boy. Between 1905 and 1907, he purchased 11 former plantations at the southern end of the Waccamaw Neck and called his estate Hobcaw Barony. Just to the north, Isaac Emerson, the inventor of Bromo-Seltzer, consolidated seven plantations and called the property Arcadia. Other notable families came as well—Yawkey and Huntington, DuPont and Vanderbilt—creating a new nobility and providing jobs and income for the area's impoverished residents.

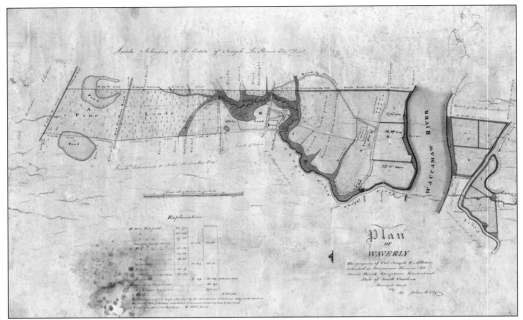

One of the major rice-growing plantations before the Civil War was called Waverly, owned by Col. Joseph Allston and shown here in a map dated 1827. There were about 70 acres of rice fields bordering the river, a "settlement," a large garden, and about a dozen "negro houses." (A.H. "Doc" Lachicotte Jr. collection.)

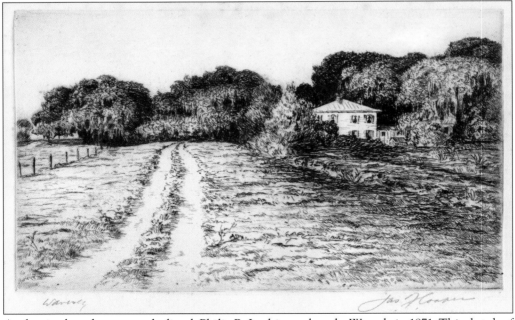

As the rice-based economy declined, Philip R. Lachicotte bought Waverly in 1871. This sketch of the old plantation is by James Fowler Cooper, who chronicled Lowcountry life in the years before World War II and sold his work at the Hammock Shops after their founding in 1938. (Alberta Lachicotte Quattlebaum collection.)

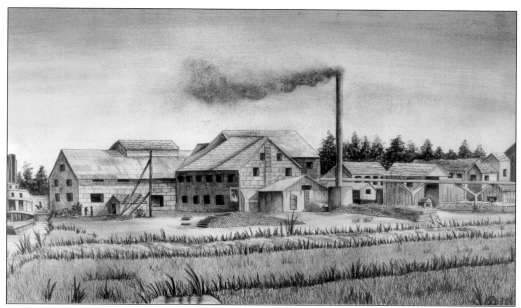

Philip Lachicotte turned Waverly into an industrial center, including a sawmill, a rice mill, a barrel-making plant, and even a dairy. This sketch and photograph show the extent of his operations. Doc Lachicotte, Philip's great-grandson and the man who made Pawleys Island hammocks famous, was born at Waverly and spent winters there. The Lachicotte family had many branches and was very entrepreneurial, operating inns and boardinghouses on Pawleys, a vegetable canning business at Litchfield Plantation just north of Waverly, and a taxi service that took tourists from the river landings to the island. (Above, Lachicotte Company; below, Alberta Lachicotte Quattlebaum collection.)

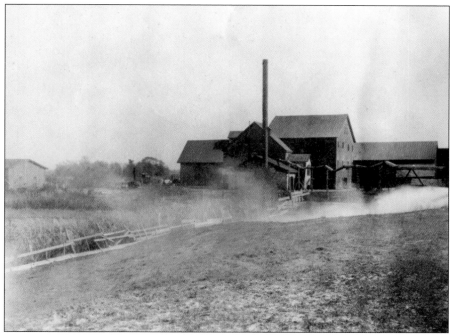

Doc Lachicotte and his sister Alberta are shown outside the kitchen at Waverly Plantation in 1930. Poverty gripped the area during the Depression, and Alberta recalls that when the banks in Georgetown failed, her family "lost everything they had. Things were pretty bad." Doc notes, however, that no one on the Waccamaw Neck went hungry because of the abundant seafood in the area. "As kids we lived in the creek," harvesting crabs, shrimp, and oysters, Doc told the Georgetown Library History Series. He attended a one-room schoolhouse and never had more than four children in his grade. After finishing that school, he attended Winyah High in Georgetown, a two-hour bus ride each way. The change was so dramatic, he jokes, that the high school seemed like a "major university." (Both, A.H. "Doc" Lachicotte Jr. collection.)

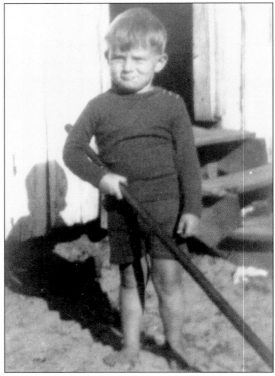

Some of the old Waverly property is still owned by the Lachicotte family, and one of the original buildings, the overseer's house, shown during a rare snow, was occupied until her recent death by Doc's sister, Alberta Lachicotte Quattlebaum. Her book *Georgetown Rice Plantations* is the definitive history of the local rice culture. (A.H. "Doc" Lachicotte Jr. collection.)

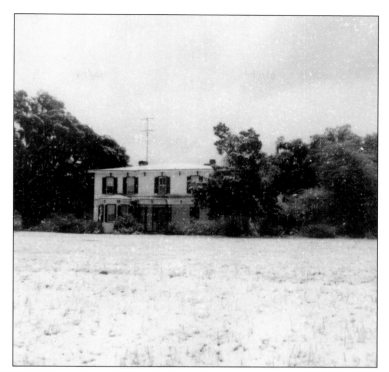

Marie Lachicotte Ward rides her horse at Waverly, with the outdoor kitchen and barn from the original plantation in the background. Kitchens were seldom located in the old houses because the risk of fire was so great. Much of the original Waverly property has been turned into homesites today. (Alberta Lachicotte Quattlebaum collection.)

No. 222

WAVERLY MILLS' TOLL SHEET.

510 Bushels Rough Rice Received from *Dr A. J. Sampson*

and pounded *Apl 28* for a/c *Georgetown Grocy Co*

36	Bbls.	Bags Whole.	Gross	13653	Tare	1188	Net	12465
5	"	" Mid.	"	1924	"	166	"	1758
2	"	" Small.	"	739	"	66	"	673

MILL CHARGES.

Freight on	510	Bush. Ro. Rice, @	2			10	20
Pounding	570	" " " @	8½			43	35
Furnishing	43	Bbls. @	50			21	50
"	1	Bags @	10				10
						$75	15

Average Tare, 33
Taking, 1022
Bus. to 300 lbs.
100

Draft drawn on you @ _____

favor.

E. E.

Apl 30, 1900

BR Lachicotte Sons

This is a rare record of the postwar era, a "toll sheet" for Waverly Mills, which processed 510 bushels of rice for Dr. Sampson of the Georgetown Grocery Company in April 1900, eleven years before the rice industry shut down completely. The bill breaks down the charges for freight and pounding, furnishing, and bagging the rice at a total cost of $75.15. A steamboat carries freight along the Waccamaw early in the 20th century, when the rivers were still the area's main highways. The cargo is uncertain, but rice was probably part of the load. (Both, GCM.)

Commercial bills provide a record of the goods that were traded along the rivers. This invoice from the Clyde Steamship Company of Georgetown in 1895 includes these freight charges: one barrel of coffee for 55¢, twenty barrels of flour for $4, and two tubs of butter for 73¢. (GCM.)

This invoice records a shipment on the Waccamaw Line Steamers on July 13, 1895, for one box of eggs and two coops of chickens. The line had three freighters—the *Maggie*, the *Ruth*, and the *Driver*—that made regular runs between Georgetown and Conway. (GCM.)

Beginning in 1890, Louis Claude Lachicotte (son of Philip R. Lachicotte, who bought Waverly in 1871) operated the first canning factory in South Carolina, packing vegetables and seafood at Litchfield Plantation. One label here is for its Hot Southern Sauce, made from "hot Southern peppers" by the Lachicotte Sauce Company of Waverly Mills, South Carolina. Celina Vaughan writes that this sauce "was preferred by many to Tabasco." Another of its product lines was Lachicotte's Yankee Sauce, and despite the odd name, it was called "a superior condiment for seafood" by Vaughan. The second label advertises "cove oysters," an attempt to market the area's bountiful seafood. (Both, Lachicotte Company.)

Caledonia was one plantation retained by the original owners, the Nesbits, well into the 20th century. On April 22, 1903, Ralph Nesbit Jr. paid Caledonia's bill with the Georgetown Grocery Co. for $434.60. The letterhead lists his post office as Waverly Mills and advertises Caledonia as a grower of "Carolina Gold Seed Rice." (GCM.)

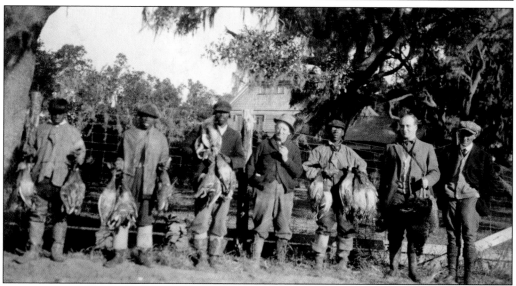

To pay the bills, Nesbit and other landowners would lease their property to hunters and fishermen, and this 1916 photograph shows a successful party of turkey hunters at Caledonia with their African American guides. Caledonia has been converted into one of the area's most attractive golf courses. (GCM.)

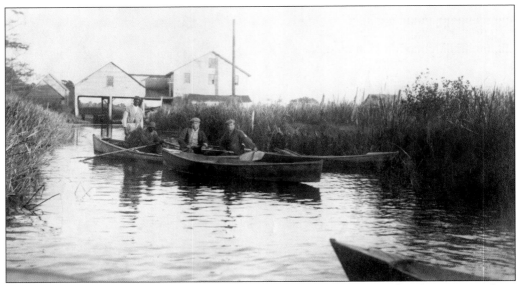

Duck hunting was a favorite pastime of the sportsmen who bought and leased the old rice plantations. Wildfowl fed on the abandoned fields and the old canals, like this one at Caledonia, provided easy access to the hunting grounds. A boathouse spans the waterway in the rear of the photograph. (GCM.)

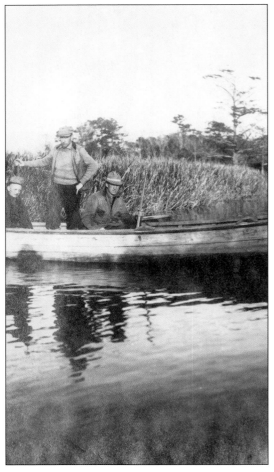

The duck hunters have left the boathouse and are waiting for their quarry. Today, the golf course at Caledonia has preserved some of the old fields and canals, and right near the clubhouse, it is possible to see a scene like this one—without the hunters. (GCM.)

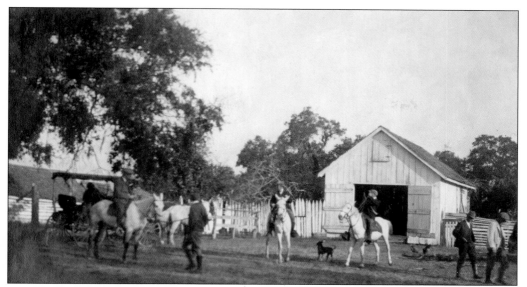

A plantation like Caledonia had large stables for horses and kennels for hunting dogs. This hunting party is about to head out on Thanksgiving 1916, a time when many of the old plantations had already been sold but Caledonia was still in the hands of the Nesbit family. (GCM.)

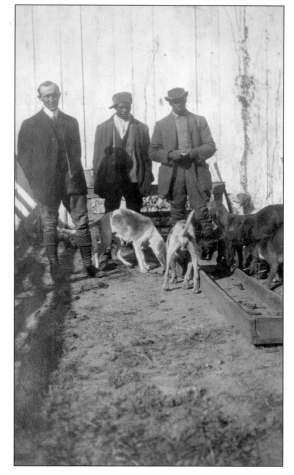

Ralph Nesbit (left) poses with two of his African American hunting guides while their dogs finish a meal. The Nesbits were among the first families to build a summer retreat on Pawleys. They named their plantation Caledonia after the Latin name the Romans used for northern Scotland, the Nesbits' ancestral home. (GCM.)

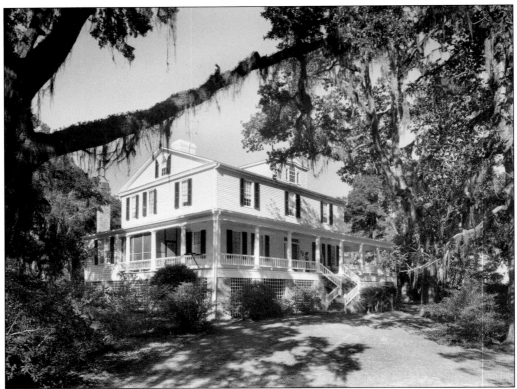

Another plantation that remained in local hands was Chicora Wood on the Pee Dee River. In 1832, it was bought by R.F.W. Allston, whose daughter Elizabeth wrote so vividly about the family's annual treks to Pawleys Island. Allston died in 1864, and after the Civil War, his widow, Adele Petigru Allston, returned to Chicora to find it in shambles. Eventually, Adele and her daughter Elizabeth raised enough money to rebuild the house and resume planting rice. Today, Chicora Wood includes almost 1,000 acres, and the main house has been meticulously restored. Eight outbuildings remain as well, including this rice threshing mill. (Both, Library of Congress.)

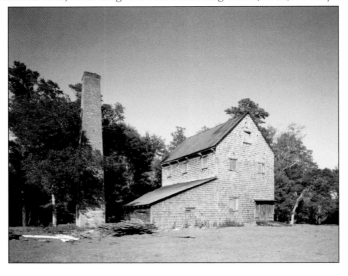

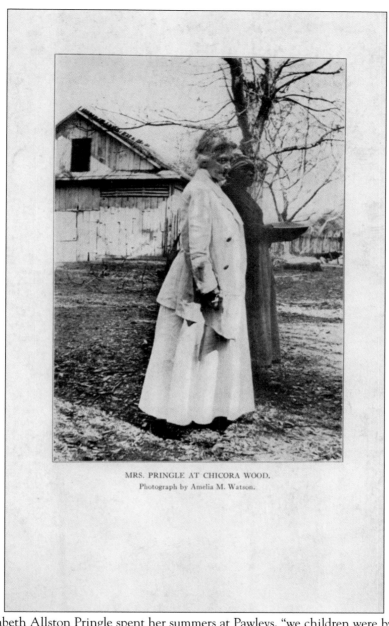

MRS. PRINGLE AT CHICORA WOOD.
Photograph by Amelia M. Watson.

When Elizabeth Allston Pringle spent her summers at Pawleys, "we children were by no means idle," she writes. "We were required to read and write and practise every day. Papa's rules were strict: we could never go out to walk or play on the beach in the afternoon unless we had done our tasks." As a result of that early training and discipline, Elizabeth became the most important source of information about 19th-century life on Pawleys and the surrounding plantations. As she struggled to make rice planting profitable again, Elizabeth needed an extra source of income. Under the pen name Patience Pennington, she started writing weekly letters for the *New York Sun*, which were collected into the book *A Woman Rice Planter*, published in 1914. Her invaluable memoir, *Chronicles of Chicora Wood*, was published after her death in 1921. (Courtesy of South Caroliniana Library, University of South Carolina, Columbia.)

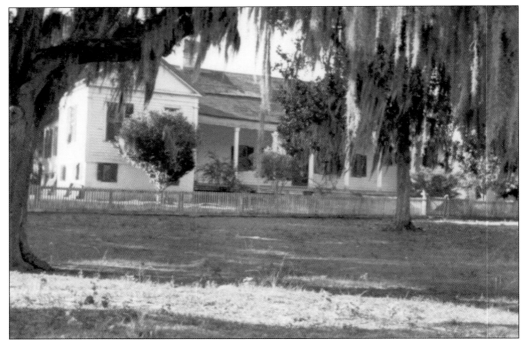

One of the "rich Yankees" to buy up plantations on the Waccamaw Neck was Isaac Emerson, the inventor of Bromo-Seltzer. Starting in 1906, he and his grandson George W. Vanderbilt assembled seven properties and renamed them Arcadia. One was Fairfield Plantation, once owned by the Allston family. The house shown here was originally built for an overseer, but when the Allston homestead at Clifton Plantation burned down, the family moved to Fairfield. Even after emancipation, many former slave families continue to live and work on the old plantations, and the photograph below, taken in about 1920, shows children at a schoolhouse on the old Fairfield property. (Both, Belle W. Baruch Foundation, Hobcaw Barony.)

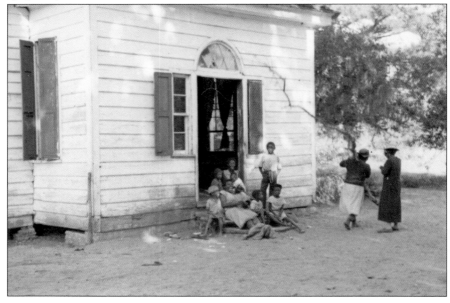

Isaac Emerson started with a small drugstore in Baltimore and created a headache remedy, which he called Bromo-Seltzer. But his real genius was understanding the value of advertising. This ad from 1895 promises that his miracle product will cure "Insomnia, Nervousness, all Headaches, Nervous Dyspepsia, and Stomach Disorders." (GCM.)

In 1911, Emerson's daughter Margaret married Alfred Gwynne Vanderbilt, one of the wealthiest men in America, who died four years later when the British liner *Lusitania* was torpedoed by a German submarine. Their son George W. Vanderbilt inherited Arcadia and was running it in 1939 when he paid this bill from C.L. Ford and Sons, the grocer in Georgetown that serviced many of the plantations. (GCM.)

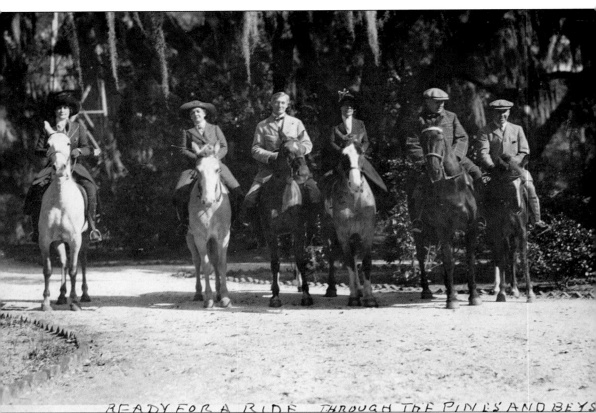

READY FOR A RIDE THROUGH THE PINES AND BEYS

Hobcaw is a Native American word meaning "between the waters." A barony was a colonial land grant, and the area known today as Hobcaw Barony was first deeded to an Englishman, Lord Carteret, in 1718. By the mid-18th century, more than a dozen plantations had been carved out of the barony, but like other plantations, they lost much of their economic value after the Civil War. In 1905, a Wall Street titan and adviser to presidents, Bernard Baruch, started buying up the old barony properties as a winter retreat for his wealthy friends. This photograph from about 1910 shows Baruch (center) and his wife, Annie (left), riding with Adm. Cary Grayson, then the personal physician to President Wilson. The photograph was made into a postcard for Baruch's visitors, who flocked here for hunting and fishing, riding, and relaxation. (Belle W. Baruch Foundation, Hobcaw Barony.)

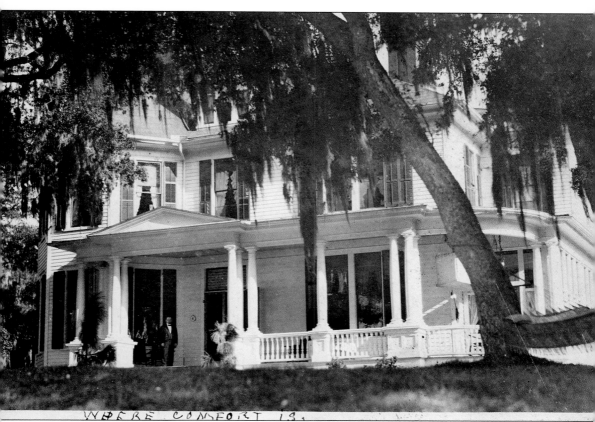

WHERE COMFORT IS.

By 1907, Baruch owned about 16,000 acres that included this stately house known as the "Old Relick," and it served as his winter quarters until it burned down in 1929. The replacement, called Hobcaw House, was made of brick, not wood, and is open to the public today for guided tours. Winston Churchill visited in 1932 and President Roosevelt stayed there in April 1944 and recounted his vacation to reporters: "In one word I have rested. I have had a very quiet time. Been out in the sun as much as possible." The president mused about how hard it is for a president to find a restful retreat that is also secure and added, "I like it here. I have been very comfortable down here. I want to come back." He died less than a year later. (Belle W. Baruch Foundation, Hobcaw Barony.)

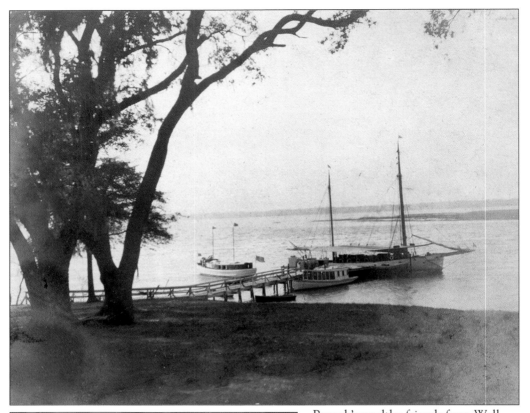

Baruch's wealthy friends from Wall Street often arrived in their own yachts and tied up at this dock jutting into Winyah Bay. Others took the train to Georgetown and were ferried across the bay in private motor launches. The Baruchs and their guests were waited on by squads of servants, including these three women who are raking the front yard and the oyster-shell path that overlooks Winyah Bay. Many of these servants were descendants of enslaved workers who continued to live and work on their old plantations long after the end of the Civil War. (Both, Belle W. Baruch Foundation, Hobcaw Barony.)

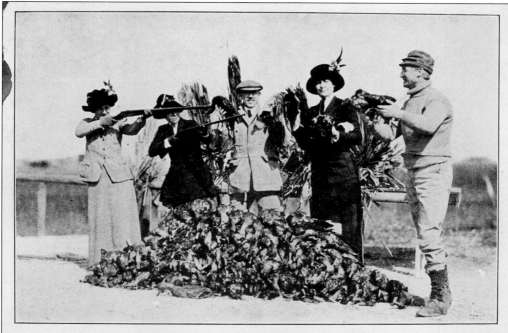

THEY ALL DID IT. FIND THE MAN WHO DID

The Atlantic Flyway for migrating waterfowl goes right over coastal South Carolina, where countless marshes and creeks provide ideal sources of food for famished flyers. In this photograph used as a postcard for Hobcaw visitors, Annie Baruch (second from right) and two other women brandish rifles over a pile of about 100 ducks. (Belle W. Baruch Foundation, Hobcaw Barony.)

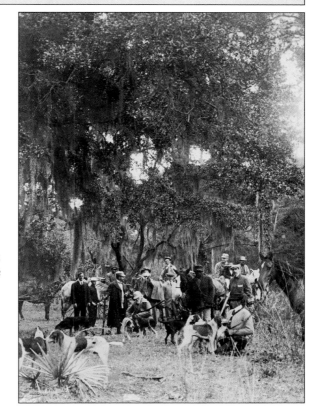

This photograph from 1907 highlights deer hunting, another favorite pastime of the "rich Yankees" who bought the old plantations. This party includes Harry Donaldson (kneeling in foreground), who built the Old Relick and sold it to Baruch, and the landowner's father, Dr. Simon Baruch (with the white goatee in the center). (Belle W. Baruch Foundation, Hobcaw Barony.)

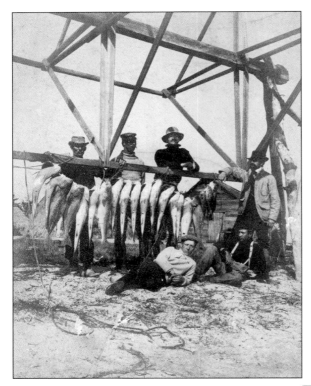

Franklin Roosevelt praised the pleasures of fishing at Hobcaw, and Baruch poses with guests and guides underneath an observation tower at Clambank Landing on the barony's shoreline. Spottail bass was a favorite game fish here in Winyah Bay and in North Inlet, still a prime fishing ground today. (Belle W. Baruch Foundation, Hobcaw Barony.)

The waterways that threaded through the old rice fields were also a source of seafood. Here, employees of Hobcaw manipulate an unusually large trap with a hefty catch of fish inside. The creeks also yielded another delicacy that even today forms a staple of Lowcountry cooking: fresh shrimp. (Belle W. Baruch Foundation, Hobcaw Barony.)

The huge barges that once carried rice to the port of Georgetown, made of native cypress, were adapted to new uses in the 20th century. This one was used to transport horses and dogs to a fox hunt up the Waccamaw from Hobcaw Barony. The boatman is identified as George Shubrick, a skilled hunting and fishing guide, whose ancestors had been slaves on the old plantations bought by Bernard Baruch. Like many African Americans in the Lowcountry, he continued to live and work on the same land long after emancipation. "Guides were expert not only in knowing when to shoot, but they had to closely watch the kill drop," notes Lee Brockington. "Guides were usually able to row and collect every kill often, prior to federal regulation, a total of 100 ducks by late morning." (Belle W. Baruch Foundation, Hobcaw Barony.)

Children gather at the door of a former slave cabin on the Hobcaw property. Four different slave villages have been identified on the old plantations that comprise Hobcaw. One of them, Friendfield Village, is remarkably well preserved and can be visited today as part of a guided tour. (Belle W. Baruch Foundation, Hobcaw Barony.)

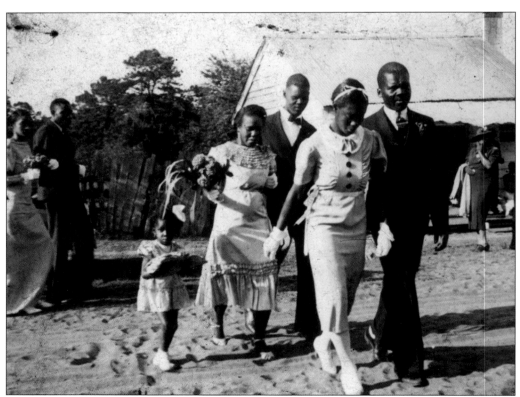

This is "a scene from a 1920s wedding in Friendfield Village at Hobcaw Barony," writes Lee Brockington. "The bridal party is crossing the street from the home of the Reverend Moses Jenkins to Friendfield Church." Descendants of slaves continued to live on Hobcaw into the 1990s. (Belle W. Baruch Foundation, Hobcaw Barony.)

Brookgreen Gardens is composed of four old rice plantations bought by Archer and Anna Hyatt Huntington in 1930. The Huntingtons created what is today a famous outdoor sculpture museum and nature preserve. One of the original plantations was called Laurel Hill, and the photograph at right shows the old family home in about 1930. Historians say it was "most likely" built by the planter Francis Marion Weston in the early 19th century. Weston's son Plowden C.J. Weston built one of the first houses on Pawleys Island, now the Pelican Inn. The image below shows the original kitchen from Brookgreen, another property purchased by the Huntingtons. (Both, Brookgreen Gardens Collection.)

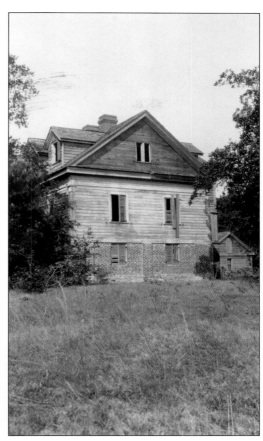

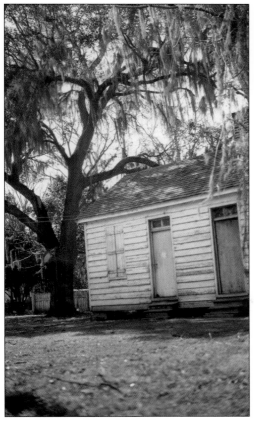

Here is the old Laurel Hill landing on the Waccamaw in about 1930, when the Huntingtons were first assembling their holdings as a winter retreat for Anna Huntington, who suffered from tuberculosis. After she recovered her strength, the couple decided to convert their property into what is today Brookgreen Gardens. The original plantation houses were often built on high ground above the river, and these steps led from Brookgreen plantation down to the Waccamaw. Joshua John Ward, one the area's wealthiest planters and owner of more than 1,000 slaves, was born at Brookgreen and owned a large tract on Pawleys. (Both, Brookgreen Gardens Collection.)

One of the saddest stories surrounding Brookgreen plantation involves Georgeanna Ward Flagg, the granddaughter of the original Joshua John Ward, the area's largest slaveholder. She married Arthur Flagg, a doctor who dispensed free medicine and advice to the plantation workers. In September 1893, the Flaggs were at their summer home at Magnolia Beach, which is today called Litchfield, when a fierce storm swamped the area. The elder Flaggs, their son Arthur Jr., and his entire family were wiped out. Another son, Dr. J.J. Ward Flagg, shown here in his old age, was the only family member to survive. (Both, Brookgreen Gardens Collection.)

Dr. Flagg lived until 1938, 45 years after the rest of his family had perished. Historians have called him the last link to the plantation era on the Waccamaw Neck. He served not just as a physician but also as postmaster, and the signs shown here reflect that dual role. The custom of the time was for rich old white men to hire a black man as a companion and servant, and the man who served Dr. Flagg, Tom Duncan, lived with his family in this house just behind his employer, on a site that is now part of the Brookgreen sculpture garden. (Both, Brookgreen Gardens Collection.)

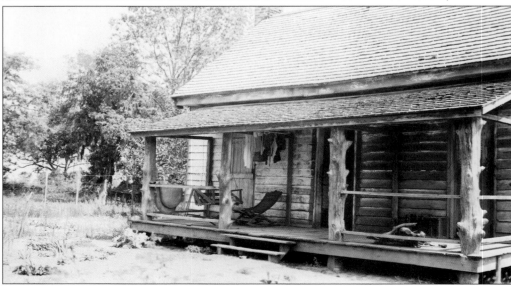

When the rice culture collapsed, it left behind remnants of that agricultural enterprise: tombstones marking the graveyard of an entire economy and lifestyle. The bricks from this old rice mill at the Oaks, now part of Brookgreen Gardens, were reused in other buildings and the metal sold for scrap during World War II. (Brookgreen Gardens Collection.)

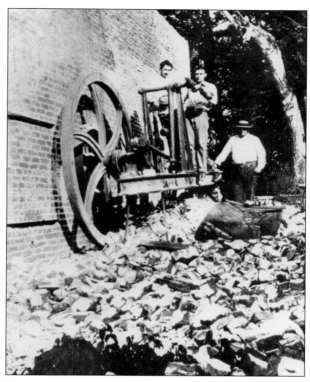

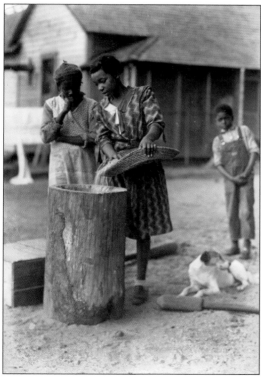

Local blacks continued to raise rice for personal use long after the market collapsed. After buying Brookgreen, Archer Huntington commissioned a photographer to document the lives of the African American families living in the area. This photograph shows women fanning rice—allowing the wind to blow away the outer husks, leaving "clean" kernels behind. (Brookgreen Gardens Collection.)

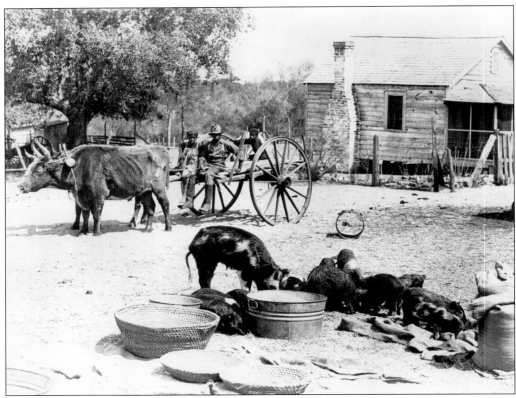

Huntington's photographer, Bayard Wootten, often focused her camera on Sandy Island, situated in the Waccamaw River near Brookgreen. Here, freed slaves bought small plots and eventually owned more than 1,000 acres. The homestead pictured above was typical of Sandy Island dwellings. Even today, no bridge connects Sandy Island, so most residents own small boats and keep a car at a mainland parking lot. (Both, Brookgreen Gardens Collection.)

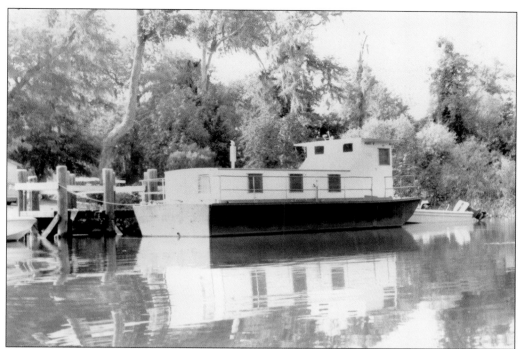

Starting in the 1950s, students had to take a school boat to the mainland for classes. That boat, the *Prince Washington*, is the only vessel of its kind in the state of South Carolina. Some Sandy Island children attended a large one-room schoolhouse on the Waccamaw Neck that was known simply as "Miss Ruby's School" in honor its longtime teacher, Ruby Middleton Forsythe. A legend in the local community, she is honored today by Miss Ruby's Kids, a "non-profit early literacy program" that prepares disadvantaged children for school. She once said, "You got to start with little things that are not in the book to teach respect. The schoolteacher today has to be mother, father, counselor, everything." (Both, Waccamaw Council.)

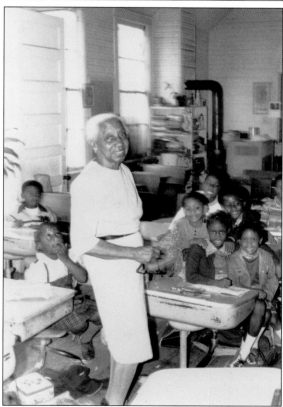

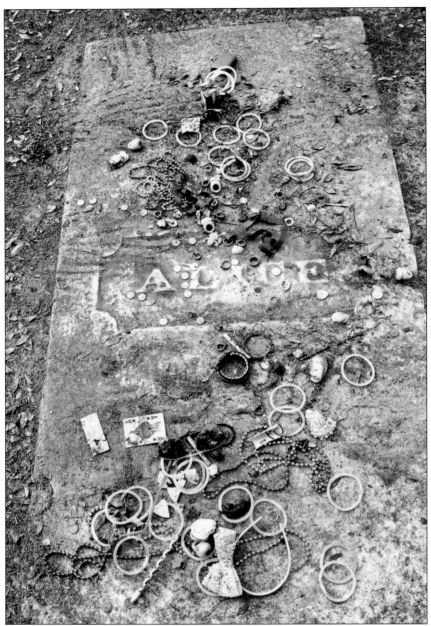

Alice Flagg fell in love with a man her wealthy family considered beneath her station. He gave her an engagement ring that she wore on a ribbon around her neck. Her brother Dr. Allard Flagg packed her off to school in Charleston to forget her betrothed. When she fell ill, he brought her back home, discovered the ring, and threw it away. She died a few days later, and legend holds that she appears periodically, all dressed in white, searching for her ring. This grave at All Saints Church is celebrated as her final resting place, but it is not—she is buried in an unmarked grave in Murrells Inlet, but the stone has become a place of pilgrimage and mystery. Visitors are constantly leaving rings and other talismans, and one myth says that if a person walks around this grave backward 13 times, Alice will appear. (Tanya Ackerman Photography.)

Five

THE HAMMOCK STORY

Mention Pawleys Island to many Americans, they often reply, "Oh, where the hammocks come from." Here's why: members of a French Huguenot family, the Rossignol de la Chicottes, were driven out of Haiti by a slave revolt in the 1790s. Descendants of those immigrants, now called Lachicotte, found work in the rice mills and plantations of the Waccamaw Neck. After the Civil War, since their wealth had not been tied up in slaves, the Lachicottes were able to buy land and start businesses of their own. After Philip R. Lachicotte purchased the Waverly plantation in 1871, he continued the planting and processing of rice, and his grandson-in-law Joshua John Ward was captain of a boat plying the rivers with rice and other cargo.

Lee Brockington continues the tale in *Island Magazine*: "In 1889 he [Capt. Ward] was uncomfortable onboard his boat and wanted to utilize a hammock to sleep above the boat's floor—to catch a breeze and avoid vermin. So he rigged a hammock with ship's rope and wooden spreaders at the ends, each made from half a wagon wheel. The knots were tied above the spreaders, and the hammock proved to be immensely more comfortable than hammocks made of cloth or barrel staves."

"The good captain passed on the art of hammock weaving to his brother-in-law, A.H. Lachicotte Sr., who made them for friends and neighbors on the island in his spare hours until hard times in the Depression forced him to develop their commercial potential," added the *New York Times*. The new bridge spanning the Waccamaw River opened in 1935, and the north–south road on the mainland near Pawleys was finally paved. The tourist trade and the hammock business were poised to expand. As Alberta Quattlebaum put it, "Thank heaven for Highway 17."

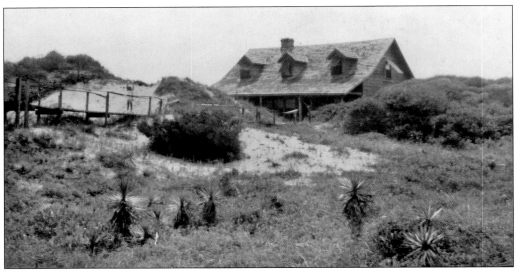

The first Pawleys Island hammocks were actually made on the island, on the ground floor of this house called Tamarisk, as a way of supplementing the family's meager income. Doc Lachicotte, the son of A.H. Lachicotte Sr., recalls weaving those early versions as a youngster with the help of black workmen. (Alberta Lachicotte Quattlebaum collection.)

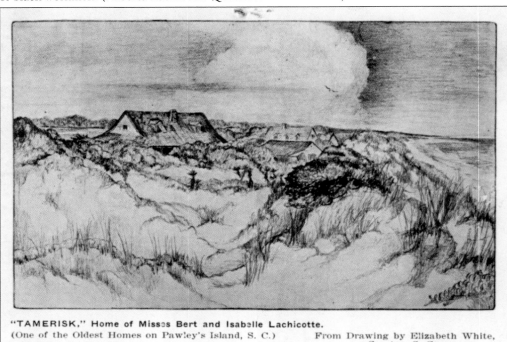

"TAMERISK," Home of Misses Bert and Isabelle Lachicotte.
(One of the Oldest Homes on Pawley's Island, S. C.) From Drawing by Elizabeth White, Sumter, S. C.

This drawing by Elizabeth White offers another perspective on Tamarisk, which was a boardinghouse run by "Miss Bert" and "Miss Belle" Lachicotte, Doc's aunts. Those first hammocks were sold "as souvenirs for beachgoers from near and far who frequented the inns, boarding houses and homes on the island," writes Lee Brockington in *Island Magazine*. (Alberta Lachicotte Quattlebaum collection.)

A.H. Lachicotte Sr. and his wife, Virginia, moved the hammock business from Tamarisk to this shop on the highway in 1938. As the sign notes, they also offered "Glassware, Pottery, Pewterware, Crafts and Nursery" to the tourist trade, and the shop was a hodgepodge of odd goods. Lachicotte Sr. greets Celeste Clinkscales, co-owner of Sea View Inn. When his son came back from the war and graduated from Clemson in 1949, the two clashed over expansion plans. "Daddy lived through the Depression and didn't see the point in building all those shops," Doc Lachicotte told *Island Magazine*. (Both, A.H. "Doc" Lachicotte Jr. collection.)

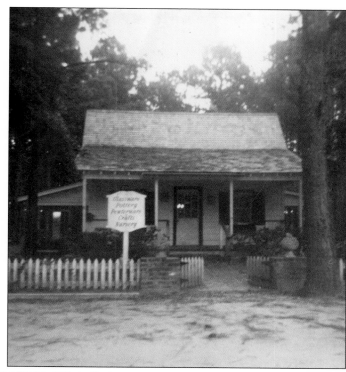

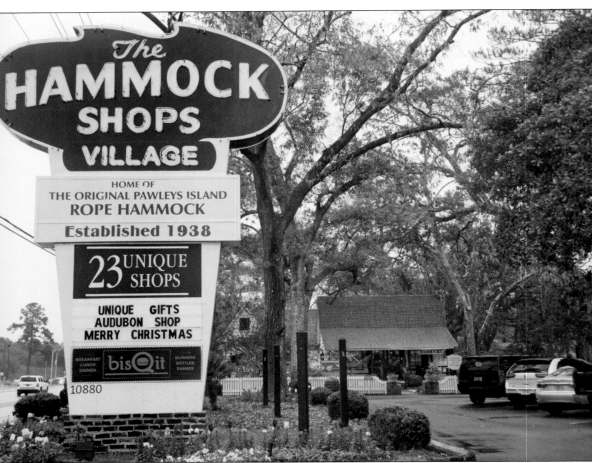

Doc married Martha Wilson, and the two gradually took over the business from his parents and became an effective team, traveling together to various shows—Martha to buy stock for their gift shop, and Doc to sell hammocks—and the New York Flower Show became an annual pilgrimage. They felt "pretty well lost in the big city," says Doc, but they were also shrewd and ambitious. "While on their trips, they saw shops designed as villages and decided to create a plantation village at the Highway 17 property," writes Lee Brockington in *Island Magazine*. They added "a shop a year" jokes Martha—including a tearoom and various retail outlets. In addition they moved buildings from Waverly—the old schoolhouse and the post office—and installed them in this complex. A giant millstone once used at Waverly was embedded in the floor of another building. (Tanya Ackerman Photography.)

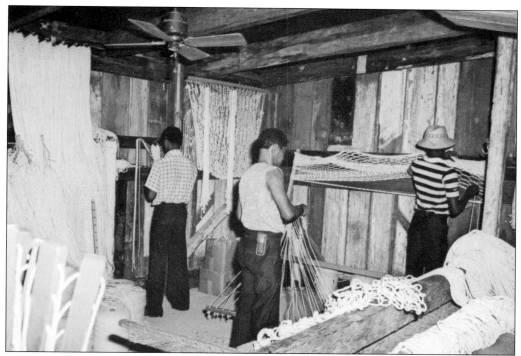

After the business moved from Tamarisk to the highway, some of the hammocks were woven on-site, mainly as a way to attract tourists and buyers. This popular postcard shows weavers at work on the Hammock Shop grounds. Most were made at a nearby factory, however, providing jobs for local workmen. Eventually, the business outgrew that factory, and as Brockington's *Island Magazine* article reports, "Today the hammocks are produced out of state—but still in America, although 90 per cent of them are shipped to Australia, Germany, France, England and even the Pacific Islands." (A.H. "Doc" Lachicotte Jr. collection, Walter McDonald Collection.)

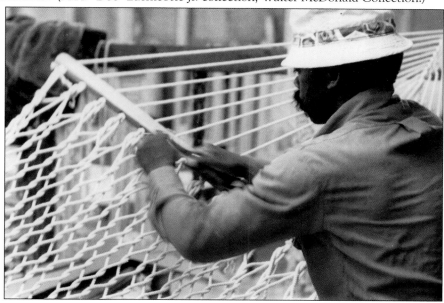

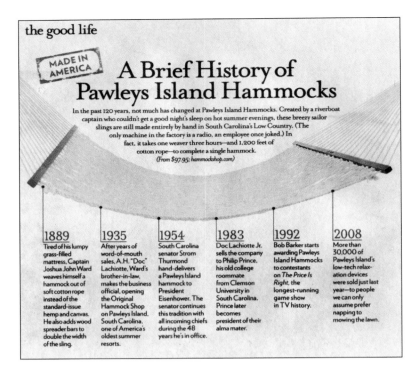

the good life

MADE IN AMERICA

A Brief History of Pawleys Island Hammocks

In the past 120 years, not much has changed at Pawleys Island Hammocks. Created by a riverboat captain who couldn't get a good night's sleep on hot summer evenings, these breezy sailor slings are still made entirely by hand in South Carolina's Low Country. (The only machine in the factory is a radio, an employee once joked.) In fact, it takes one weaver three hours—and 1,200 feet of cotton rope—to complete a single hammock.

(From $97.95; hammockshop.com)

1889
Tired of his lumpy grass-filled mattress, Captain Joshua John Ward weaves himself a hammock out of soft cotton rope instead of the standard-issue hemp and canvas. He also adds wood spreader bars to double the width of the sling.

1935
After years of word-of-mouth sales, A.H. "Doc" Lachiotte, Ward's brother-in-law, makes the business official, opening the Original Hammock Shop on Pawleys Island. South Carolina, one of America's oldest summer resorts.

1954
South Carolina senator Strom Thurmond hand-delivers a Pawleys Island hammock to President Eisenhower. The senator continues this tradition with all incoming chiefs during the 48 years he's in office.

1983
Doc Lachiotte Jr. sells the company to Philip Prince. his old college roommate from Clemson University in South Carolina. Prince later becomes president of their alma mater.

1992
Bob Barker starts awarding Pawleys Island Hammocks to contestants on *The Price Is Right*, the longest-running game show in TV history.

2008
More than 30,000 of Pawleys Island's low-tech relaxation devices were sold just last year—to people we can only assume prefer napping to mowing the lawn.

This ad highlights some landmarks in hammock history: in 1954, Sen. Strom Thurmond hand-delivered a hammock to President Eisenhower; in 1992, the popular TV game show *The Price Is Right* started awarding hammocks as prizes; and by 2008, about 30,000 "low tech relaxation devices" were being sold annually. Advertisements in high-level outlets like the *New Yorker* were critical to the company's success. (GCM.)

Rivals have tried over the years to market ersatz versions of the hammocks, but they have never succeeded. The original design has been updated with more resilient kinds of rope, but the essential character remains unchanged. This metal label attached to each "original" Pawleys Island hammock tells buyers they are getting the real thing. (A.H. "Doc" Lachicotte Jr. collection.)

Six

PAWLEYS AT MIDCENTURY

After the decline of the rice culture and the hard years of the Depression, modern-day Pawleys began to take shape as a destination for sun-seeking vacationers. One small sign of how the economic power in the Waccamaw Neck had shifted from rice to tourism, from the rivers to the sea: the post office that had long been located at Waverly Mills on the Waccamaw was moved to a store on Highway 17 in 1939, and the address was changed to Pawleys Island.

The main attraction was still the beach, the timeless beach, but inevitably other tourist services grew up as well—shops and restaurants, motels and dance halls, amusement parks, and ice-cream stands. Doc Lachicotte always said that every business in town needed one rainy day each week to drive the tourists inside and spend money.

The biggest boost was the coming of golf. Litchfield Plantation was converted into a golf course in the early 1960s, and many others followed. The plantations were perfect for the purpose: large tracts of undivided land, with natural watercourses and gently rolling terrain. Golf extended the tourist season far beyond the beach months of high summer, and it also lured retirees to the area, especially younger folks with lots of free time and money who wanted a place to stay vigorous and healthy. Today, golf clubs contend with sea oats and hammocks as the symbol of Pawleys.

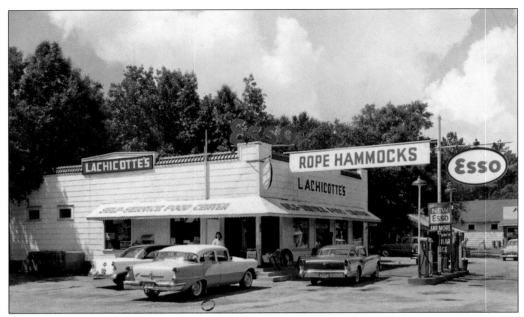

Another branch of the Lachicotte clan opened a grocery store in the mid-1920s that also provided an outlet for the hammock-making side of the family. The store's innovations included bringing ice up the river and selling it out of an icehouse on the premises. It also became the post office and local hangout. (GCL.)

Hammocks formed only part of Doc Lachicotte's business interests. A horticulture major in college, he opened a nursery after graduating from Clemson in 1949 that served many of the old plantations and later branched out into real estate. The Lachicotte family still runs the real estate office. (A.H. "Doc" Lachicotte Jr. collection.)

The first stores in the area were located on the old River Road, which threaded through the plantations near the Waccamaw River. One, called Grab All, is mentioned in *Scarlet Sister Mary*, the 1928 Pulitzer Prize–winning novel by Julia Mood Peterkin. Across the road, Take Some was notable because it "had a crank telephone that occasionally provided long distance contact with the outside world," writes Celina Vaughan. Traffic gradually shifted eastward to Highway 17, and in 1943, Harry Marlow opened a small store on land that had been part of True Blue Plantation. Marlow's Super Market became a central feature of island life—part grocery, part general store, part community center. Harry's son Frank took it over in 1947, and in 1988, a former clerk at the store, Salters McClary, converted the old place into a popular upscale restaurant called Frank's. (Marlow family collection.)

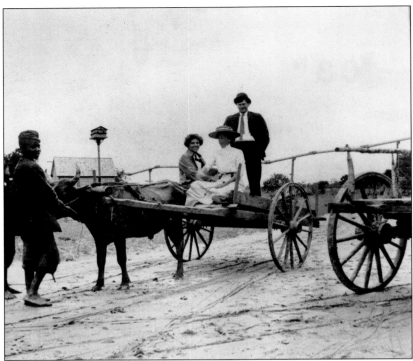

Cars were still scarce even after the roads improved, and on Pawleys itself, muddy tracks that flooded frequently were often navigated more efficiently by animals than by autos. This photograph shows A.H. Lachicotte Sr. (who was also known as "Doc") standing in the back of an ox-drawn cart. (A.H. "Doc" Lachicotte Jr. collection.)

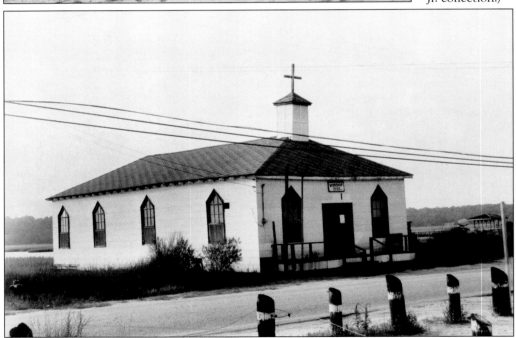

The growing tourist population spawned many services, including the Pawleys Island Chapel, built over the marsh in 1948 near the old Tamarisk house. The chapel has long been a popular venue for weddings; on busy June weekends, it is entirely booked, and the nearby beach is littered with picture-taking wedding parties. (Waccamaw Council.)

Small inns and boardinghouses proliferated. Celina Vaughan writes that, in the 1920s, "room and board for adults was twelve dollars per week in the boarding houses and the family rates were even less." This sign advertises three early tourist houses: the Tavern, the Brinkley Inn, and the Tip Top Inn. (GCL.)

The continuing growth of the Pawleys community is reflected in the peripatetic post office that kept moving: first from Waverly Mills on the river to Lachicotte's store on the highway and, finally, to its own building. The original Waverly Post Office actually moved too and is now located in the Hammock Shops complex. (GCL.)

The sign on the previous page points to the Tavern and underneath is written "Mrs. Ellerbe." This establishment was run for several generations by the Ellerbe family until 1979 and is shown during a rare snowstorm. The name was changed to Ellerbe Inn to make it more family friendly. (Ellerbe family collection.)

The name change reflected the Ellerbes' emphasis on families, and one of the favorite evening activities on Pawleys was card-playing. An Ellerbe descendant writes, "Young and old alike sat around the round table in the living room and enjoyed playing poker. Two cent gambling limit, though—house rules." (Ellerbe family collection.)

At Ellerbe's, meals were served family style in a big dining room. Each inn had its own specialties, but most depended heavily on local seafood and the traditions and ingenuity of the women, many of them black, who presided over the kitchen. Elizabeth Bryant and Florence Dereef ran the Ellerbe operation for many years. These cooks, or their emissaries, would often gather on the beach and buy dinner directly from the fishing boats pulled up on the shore. Other men would gig for flounder at night in the creek and walk from house to house, hawking their catches the next morning. (Both, Ellerbe family collection.)

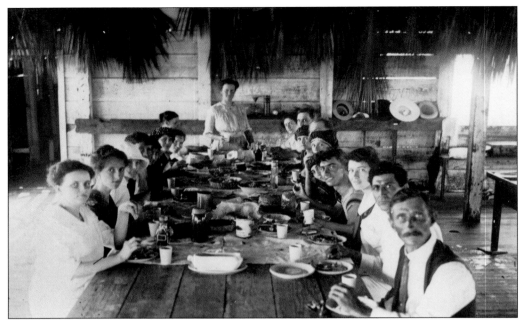

The Atlantic Coast Lumber Company was not the only employer to use Pawleys as a retreat for its workers. In this photograph, the employees from the telephone company in Georgetown enjoy an annual beach outing. The setting is typical of boardinghouse meals: long outside tables and many hungry diners. (Morgan Trenholm Collection.)

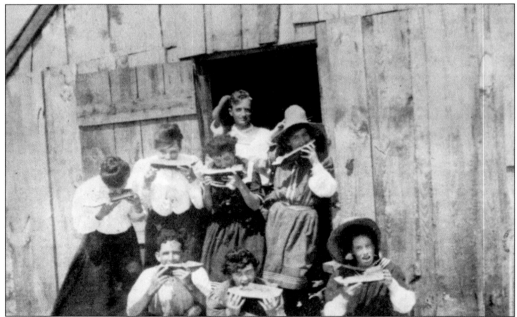

Along with fresh seafood, Pawleys Island menus have always included locally grown fruits and vegetables. Corn and tomatoes, okra and beans, and peaches and plums—often bought at roadside stands that sprout up during the summer—grace every table. This happy clan is devouring a watermelon, always a favorite summer treat then and now. (GCL.)

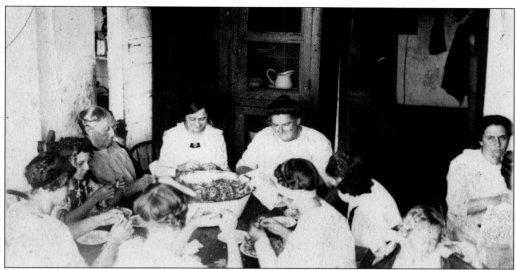

Tamarisk was not only the birthplace of the Pawleys Island hammock, as the Lachicotte family ran it as a boardinghouse for many years. If eating was usually a communal activity in these establishments, so was preparing food. Fresh seafood required considerable work before it got to the table, and here, members of the extended Lachicotte clan engage in a messy but necessary task: heading shrimp. The workers range over many generations, and no men are present. What the men seem to be good at is sitting on the back porch at Tamarisk. Note the auto parked at right in this 1920s photograph. (Both, Alberta Lachicotte Quattlebaum collection.)

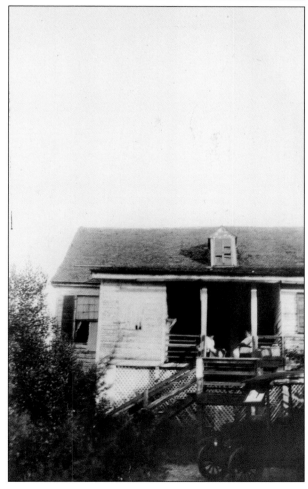

The Lachicotte sisters Bert and Belle managed Tamarisk but also had a sideline—a dairy business that provided fresh milk to the surrounding inns and boardinghouses. The family still owned a piece of the old Waverly plantation, and that is where the cows were quartered. Doc Lachicotte recalls being roped into the milking business by his aunts, and he vowed that "if I made enough money I'd never milk another cow." The milk was then transported across Waccamaw Neck to Pawleys Island on a cart pulled by two well-known local figures: the donkeys Little One and Vista. (Both, Alberta Lachicotte Quattlebaum collection.)

When times got hard, many families rented out rooms, cooked meals, sold fish, and provided other services to the burgeoning tourist trade. The Pearce family operated the Periwinkle Tea Room in a house just off the north causeway, and a menu from that esteemed establishment is shown here. (Pearce family collection.)

- MENU -

Periwinkle Inn

Pawleys Island, S. C.

These advertisements reflect the range of businesses servicing the tourist trade. The Rusty-Ann Lodge boasts that only "the very best people" bother to eat there. A gas station offers both overnight rooms and car repairs. Ads for fishing, sailing, and beachcombing use the same reassuring word: *safe*. (GCL.)

FISHING: DEEP SEA — CHANNEL — FRESH WATER

CAPT. C. M. RAYMOND
SPECIALIZING IN CHARTER PARTIES

Safe, Fast 26 Foot Boat, Twilldu III

ENQUIRE AT PAWLEYS ISLAND OR THE CHAMBER OF COMMERCE

We Invite You To Visit

PAWLEYS ISLAND ═══ ═══ SERVICE CENTER

· Modern Overnight Cabins
. . . Amoco Service Station . . .

COMPLETE AUTO REPAIR GARAGE

ON U. S. 17 · BETWEEN THE TWO CAUSEWAYS

PAWLEYS ISLAND BEACH IS SAFE ! ! !

JOY & GOOD HEALTH FOR EVERYONE

YOU ARE CORDIALLY INVITED

The Very Best People
. Drive Miles To Eat At

Rusty-Ann Lodge

Only 11 Miles North Of Georgetown
Just Off U. S. Route 17

The Carolina Court . . . U. S. 17, Pawleys Island, S. C.

Folks driving through on the improved highway needed a place to stay. This postcard for the Carolina Court shows the road was still only two lanes (it is four today), but traffic grew fast enough to support a motel described as "new and modern with most up-to-date furniture, quiet and convenient." (GCL.)

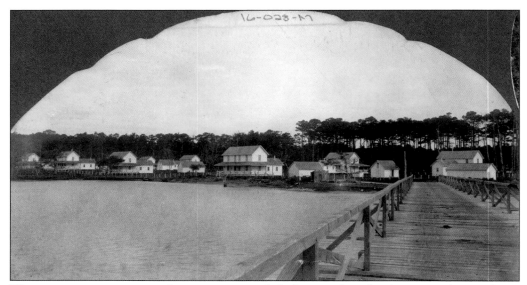

The new tourists were not always content with lodging in boardinghouses and inns. Some families did start leasing out their homes, but there was a rising demand for new properties, and these houses were built on the creek, just south of the north causeway, primarily as rental units. (Morgan Trenholm Collection.)

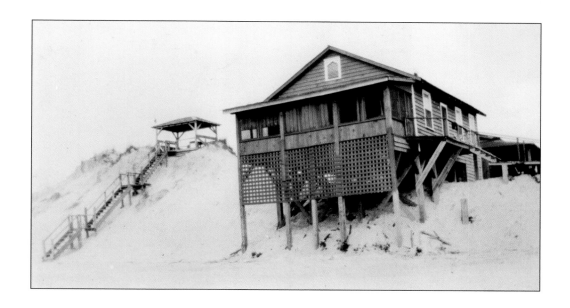

An entrepreneur named Fred Brickman saw the rising market for rental houses and built six of them on oceanfront property he called Lafayette Court. One image shows a building from the seaward side; the other, a wooden walkway down the middle of the "court," which included a pool hall and gas station. Brickman also innovated by advertising his properties, and a promotional brochure boasted that the island's "salt water tides are positively destructive to mosquito larvae and hence the island is practically free of mosquitoes, which are common at less-favored beaches." Four of the original houses survive and are available for rental. (Both, GCL.)

As roads and cars improved and gas stations proliferated, Brickman sensed another trend in the tourist business: families could now drive to the island, spend a day at the beach, and then drive home without staying over. He built these showers and changing cabanas at Lafayette Court to accommodate day-trippers and lured families with the promise that Pawleys had "never [had] a drowning in memory of man." Another of his advertisements boasted that Lafayette Court Cottages were "screened with copper wire, have electric lights, running water furnished from a 550-foot deep flowing well, modern plumbing, enclosed showers on boardwalk." (Both, GCL.)

Many of the inns and boardinghouses have faded away but the Sea View Inn survives. It was built in 1937, just north of Lafayette Court, by Will and Celeste Clinkscales. One historian writes that for the next 15 years, "Will's brother George lived next door, kept turkeys and chickens under his house, to the south of the inn and fired a cannon each day during the inn's rest hour." Two of the inn's most popular activities: rocking and chatting on the porch (there really is a sea view), and eating at the long tables in the dining room. (Both, Sea View Inn.)

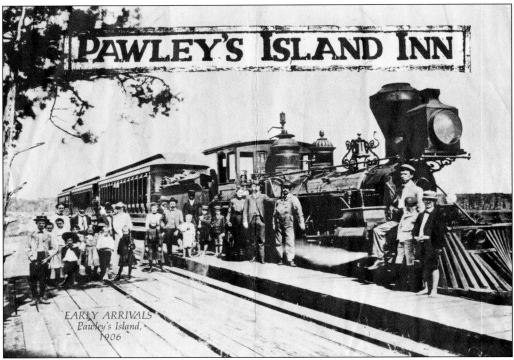

EARLY ARRIVALS
Pawley's Island,
1906

As the Hammock Shops grew, the complex added several restaurants including the Pawleys Island Inn. This menu features a rendering of the train that once took visitors from Hagley Landing on the Waccamaw to the island. Inside, the menu exaggerates with the promise that Pawleys is a "living legend" where "the sun shines a little brighter" and "the moonbeams are just a bit softer." As for the food, the menu boasts that "cracklin' cornbread and Florence's biscuits are the inn's indisposable commodity"; perhaps they meant "indispensable." The fish chowder, "an Inn thing," says the menu, goes for $1.10 per cup. (Both, GCM.)

LOW COUNTRY FAVORITES

BEACH BOWL
French fried fresh mushrooms and onion rings served together or separately. Simply scrumptious with the Inn's sauce.
Mushrooms 1.65 Onion Rings 1.15
Together 1.55

BEACHCOMBER'S FIND
A generous serving of the Inn's special paté made with tuna, pistachios, and our special seasoning. 1.60

SALT MARSH GOOBERS
Peanuts boiled in salted water and served cold in the shell .75

CAROLINA COCKTAILS
From nearby creeks and inlets with our tangy seafood sauce
Shrimp Cocktail 2.35 Oyster Cocktail 2.00

THE SALAD GARDEN
A salad from the garden is almost a meal in itself, served with wafers.

TUNA SALAD
Chunks of tuna and eggs with crunchy bits of celery and onion with the Inn's distinctive dressing 2.25

SHRIMP SALAD
South Carolina shrimp with celery, onion, potato, and a special dressing 3.45

FRUIT SALAD
Cottage cheese mounded on garden lettuce with a combination of fresh fruits of the season and other fruits prepared with our house dressing 2.75

THE INN'S GARDEN SALAD
Fresh greens, wedges of tomato, mushrooms, julienne of imported Swiss, turkey, baked ham and scallions 3.75
The Garden Salad served with your choice of House or Blue Cheese Dressing. (The Blue Cheese comes from Clemson University and rumor has it that it is made from pure Tigers milk. Gamecocks may prefer our House Dressing!)

SEASHORE SOUPS

ISLAND INN HE CRAB SOUP
A blend of McClellanville crabmeat, sherry and other good things cup 1.25

OUR FISH CHOWDER
An Inn thing cup 1.10

GAZPACHO
A chilled liquid salad. A blend of fresh tomatoes, peppers, cucumbers, olive oil and lemon juice. A summertime treat. cup 1.10

MAINLAND FARE

Super deli sandwiches are specialties of the Inn. Each sandwich is stuffed with slices of choice meat, and served on your choice of rye, pumpernickel, or seed roll with potato chips and a crisp slice of dill pickle.

REUBEN
Corned beef, sauerkraut, served hot with melted Swiss cheese, mustard 2.45

TURKEY
Sliced breast white meat, lettuce, mayonnaise 2.25

ROAST BEEF
Juicy roast beef, mayonnaise 2.25

HAM AND SWISS
Baked ham, imported Swiss, mustard and mayonnaise 2.25

"LITTLE DOC" SPECIAL
For our younger visitors, a just like homemade peanut butter and jelly sandwich with your choice of drink and an OREO 1.35

CRACKLIN' CORNBREAD AND FLORENCE'S BISCUITS ARE THE INN'S INDISPOSABLE COMMODITY — BAKED FRESH IN OUR KITCHEN. CORNBREAD AND BISCUITS ARE SERVED WITH THE MID-DAY BUFFET AND OUR ENTREES.

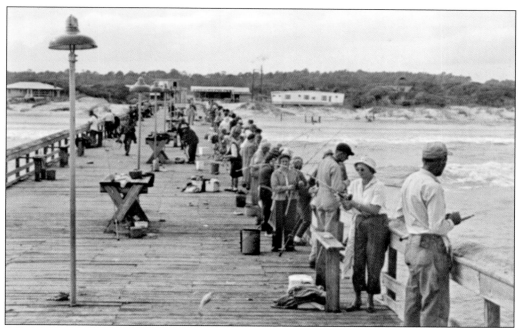

A long pier was built into the ocean in the center of the island to accommodate fisherfolk who did not want to buy a boat or get their feet wet. It is still used today but limited to guests of the condominiums that were built just east of the north causeway. (GCL.)

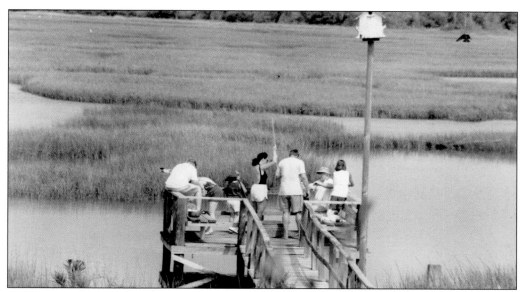

Pawleys people are divided between north-enders and south-enders and ocean-siders and creek-siders. The creek-siders love their docks, where they keep boats, net crabs, catch flounder, and raise a glass at the end of the day. Even devoted ocean-siders admit that the best place to watch sunsets is over the creek. (Sea View Inn.)

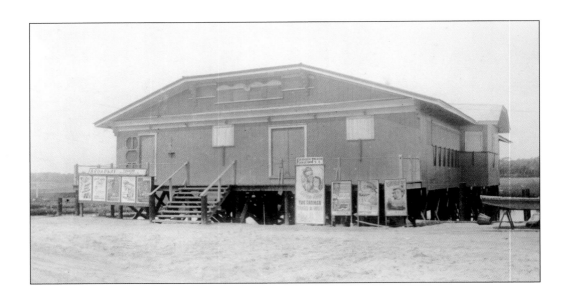

For young people at the beach, evening beckons as a time to drink and dance, meet and mate. Pawleys was home to four different "pavilions," or dance halls. This one, the third, opened in May 1935, and a year later, the *Georgetown Times* reported that "King Oliver and his Brunswick recording orchestra of 14 artists will play for the opening dance at Pawley's Pavilion Saturday night . . . large crowds coming from nearby towns are anticipated for the opening affair." The crush of cars on the narrow beachfront road show how popular the place was. Writing in *South Carolina Magazine*, Dr. Robert Quinn recalled the fire that consumed his old haunt in 1957 and suggested "some Puritan vengeance pursues the palaces of our youthful pleasure." A fourth pavilion was erected in 1960, but it burned down 10 years later and was never replaced. (Both, GCL.)

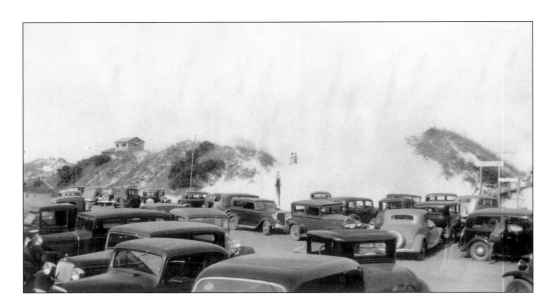

Like all communities on the Atlantic coast, Pawleys was heavily impacted by World War II. Fears ran high that German spies would try to infiltrate through local ports and beaches, and enemy submarines lurked off the coast. A recently translated diary of a U-boat commander notes he approached within a half mile of the coast while laying mines outside Charleston Harbor. Blackout shades were mandated on oceanfront homes, civilian volunteers patrolled local beaches, and a watchtower was built on the north end of Pawleys. An Army airfield was established at Myrtle Beach, training flights flew regularly over the island, and the "crash boat station" pictured here was created at Murrells Inlet to hunt for downed pilots. (Both, Murrells Inlet 2020.)

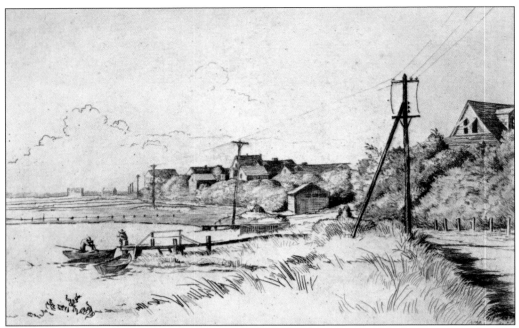

Pawleys has always attracted artists as well as writers. The landscape is subtle not spectacular, the colors muted not garish, but certain scenes almost demand to be painted or drawn or sketched: the sea oats and the marsh grasses, the docks and walkways, and beach life and birdlife. The Hammock Shops have long featured the work of local artists and other galleries have flourished in the area as well. This sketch by James Fowler Cooper shows the back road on Pawleys that floods constantly. Elizabeth White drew the marsh at high tide, but the caption is wrong—no Pawley ever owned a house on Pawleys Island. (Both, Alberta Lachicotte Quattlebaum collection.)

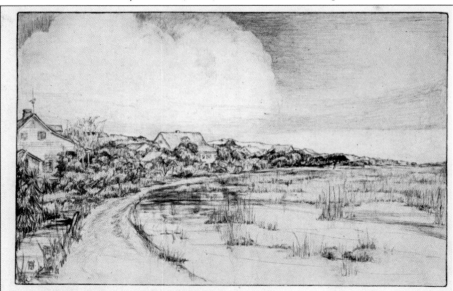

THE MARSH, Pawley's Island, S. C., at High Tide
(Mr. George Pawley, an Indigo Planter, built the first house on this island which he owned in about 1750.)

From Drawing by Elizabeth White, Sumter, S. C.

MARY ANNE McCARLEY © MCMLXXXVI

THE GRAY MAN

The Weather Channel series *American Super/Natural* includes the Gray Man of Pawleys Island. This spirit, intones the announcer, has been "haunting these shores for centuries." His mission: to warn residents of an approaching storm. One version says he was a lovesick swain who sank in quicksand while crossing a marsh to see his beloved. Another describes him as a Confederate veteran—hence the gray clothing—who drowned after returning from the war and finding his lover married to someone else. The website Mysterious Universe writes, "Five hurricanes have battered Pawleys Island over the past 200 years, including Hurricane Hazel in 1954 and Hurricane Hugo in 1989. If the stories are true, the Gray Man has appeared on Pawleys Island before each of the deadly storms." Local businesses are named for him, and revelers dress up as the Gray Man for the Fourth of July parade; he is the subject of numerous artworks, like this fanciful painting by Mary Anne McCarley. (Family of Mary Anne McCarley.)

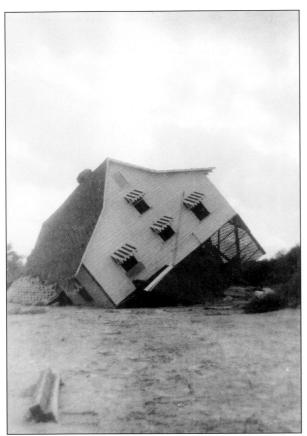

Storms are an inevitable part of life for any seaside community, and even if the Gray Man issues a warning the damage can be severe. Hazel, in 1954 (left), and Hugo, in 1989 (below), wreaked havoc with many beachfront homes, as well as trees, walkways, docks, and just about anything else in their paths. Hugo was so powerful that it cut Pawleys in two, creating a new channel that isolated the south end from the rest of the island. Newer homes are built on sturdy posts, higher off the ground, but they still provide limited protection from the worst storms that seem to hit once every generation. (Both, GCL.)

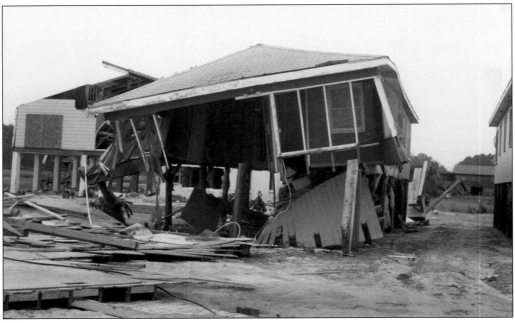

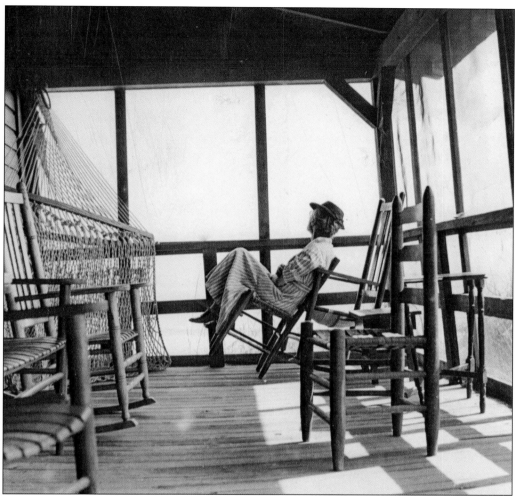

People do lots of things at Pawleys to amuse themselves. They read books, bait hooks, cast lines, find shells, sink putts, throw clubs, row kayaks, raise sails, knit sweaters, deal cards, solve puzzles, fly kites, clean fish, steer boats, sing songs, swing racquets, slice tomatoes, grill steaks, shuck corn, shred lettuce, play records, paint pictures, tend gardens, toot horns, toss balls, greet friends, walk beaches, pet dogs, pile sand, run miles, ride bikes, pick berries, bake pies, peel shrimp, fry oysters, dig clams, surf waves, take naps, teach kids, drink beer, sip wine, count stars, recite poems, browse bargains, visit graves, buy art, tell stories, watch movies, rock chairs, mix cocktails, greet sunrises, admire sunsets, spread blankets, inflate toys, build castles, arrange flowers, love life, and avoid work. But there's one thing Pawleys people do best: nothing at all. (Kaminski Prevost Collection.)

Discover Thousands of Local History Books
Featuring Millions of Vintage Images

Arcadia Publishing, the leading local history publisher in the United States, is committed to making history accessible and meaningful through publishing books that celebrate and preserve the heritage of America's people and places.

Find more books like this at
www.arcadiapublishing.com

Search for your hometown history, your old stomping grounds, and even your favorite sports team.